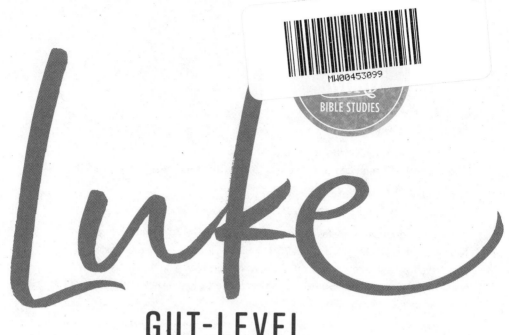

Luke

GUT-LEVEL
COMPASSION

BIBLE STUDY GUIDE + STREAMING VIDEO

EIGHT SESSIONS

LISA HARPER

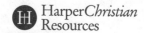

HarperChristian
Resources

Luke Beautiful Word Bible Study

© 2023 by Lisa Harper

Requests for information should be addressed to:
HarperChristian Resources, 3900 Sparks Dr. SE, Grand Rapids, Michigan 49546

ISBN 978–0–310–14134–1 (softcover)
ISBN 978–0–310–14135–8 (ebook)

HarperChristian Resources titles may be purchased in bulk for church, business, fundraising, or ministry use. For information, please e–mail ResourceSpecialist@ChurchSource.com.

The author is represented by Alive Literary Agency, www.aliveliterary.com.

First Printing February 2023 / Printed in the United States of America

22 23 24 25 26 LBC 5 4 3 2 1

CONTENTS

WELCOME

Beautiful WORD BIBLE STUDIES

Luke

GUT-LEVEL COMPASSION

SOMETIMES the Bible can seem overwhelming. Where do you go for words of comfort when you're feeling discouraged, lost, or frustrated in life? What book of the Bible do you turn to for wisdom about the situation you find yourself in?

The Beautiful Word Bible Studies series makes the Bible come alive in such a way that you know where to turn no matter where you find yourself on your spiritual journey.

Of the 66 books in our canonized Bible, all were written by Jewish authors or they're anonymous, except for the duo written by Luke—the Gospel of Luke, and its sequel, the Book of Acts.

Written around 60 A.D., Luke crafted a two-volume, structured account of the life of Jesus and the growth of the early church. The Gospel begins with the birth of Jesus in the context of Roman history and rule, then follows Jesus as he travels from Galilee through Samaria and Judea to Jerusalem.

As a non-Jew and outsider, we should not be surprised that Luke writes to highlight those seen as outliers and outcasts, those deemed misfits and unfit. Time and time again, Luke takes conventional thinking and just flips it on its head. He takes the least of these, the unlovely, the impoverished, the invisible, and he brings all of them to Jesus, who embraces them with a deep, visceral, active compassion that changes their lives forever.

If you have ever struggled with feeling like you aren't quite good enough or maybe you don't fit in, then this beautiful book is for you! You're invited to run into the arms of Jesus and experience the fullness of his gut-level compassion unlike any other love you will ever know.

> Time and time again, Luke takes **conventional** thinking and just **flips** it on its head.

HOW TO USE THIS GUIDE

GROUP INFORMATION AND SIZE RECOMMENDATIONS

The Beautiful Word *Luke* video study is designed to be experienced in a group setting such as a Bible study, small group, or other Sunday school class. Of course, you can always work through the material and watch the videos on your own if a group is unavailable. Maybe call a few friends or neighbors and start your own!

After opening with a short activity, you will watch each video session and participate in a time of group discussion and reflection on what you're learning both from the video teaching and the personal Bible study between meetings. This content is rich and takes you through the entire Gospel, so be prepared for a full experience of the depth of Scripture.

If you have a larger group (more than twelve people), consider breaking up into smaller groups during the discussion time. It is important that members of the group can ask questions, share ideas and experiences, as well as feel heard and seen—no matter their background or circumstance.

MATERIALS NEEDED AND LEADING A GROUP

Each participant should have his or her own study guide. Each study guide comes with individual streaming video access (instructions found on the inside front cover). Every member of your group has full access to watch videos from the convenience of their chosen devices at any time—for missed group meetings, for rewatching, for sharing teaching with others, or watching videos individually and then meeting if your group is short on meeting time and that makes the group experience doable and more realistic. We have worked very hard to make gathering around the Word of God and studying accessible and simple.

This study guide includes video outline notes, group discussion questions, a personal Bible study section for between group meetings, Beautiful Word coloring pages, and Scripture memory cards to deepen learning between sessions.

There is a Leader's Guide in the back of each study guide so anyone can lead a group through this study. A lot of thought has been put into making the *Beautiful Word Bible Studies* series available to all—which includes making it easy to lead, no matter your experience or acumen!

TIMING

The timing notations—for example, 20 minutes—indicate the length of the video segments and the suggested times for each activity or discussion. Within your allotted group meeting time, you may not get to all the discussion questions. Remember that the *quantity* of questions addressed isn't as important as the *quality* of the discussion.

Using the Leader's Guide in the back of the guide to review the content overview of each session and the group discussion questions in advance will give you a good idea of which questions you will want to focus on as a leader or group facilitator.

FACILITATION

Each group should appoint a facilitator who is responsible for starting the video and keeping track of time during the activities and discussion. Facilitators may also read questions aloud, monitor discussions, prompt participants to respond, and ensure that everyone has the opportunity to participate.

OPENING GROUP ACTIVITY

Depending on the amount of time you meet and the resources available, you'll want to begin the session with the group activity. You will find these activities on the group page that begins each session. The interactive icebreaker is designed to be a catalyst for group engagement and help participants prepare and transition to the ideas explored in the video teaching.

The leader or facilitator will want to read ahead to the following week's activity to see what will be needed and how participants may be able to contribute by bringing supplies or refreshments.

OUTLIERS, OUTCASTS, AND THE OUTRAGEOUS MERCY OF GOD

Opening Group Activity (10-15 MINUTES)

WHAT YOU'LL NEED:

One sheet of blank paper for each person
Pens, markers, and/or colored pencils

1. Use the paper and drawing/writing tools to write the words, "I Am Seen, Accepted, Included, and Deeply Loved" on the top of the page. Then Circle ⬭ the phrase that's easiest for you to believe and underline that one that's the most challenging for you.

2. Share your words or phrases with each other as you discuss the following questions:

 Which phrase or word is easiest for you to believe? Why?

 Which phrase or word is hardest for you to believe? Why?

 Reflecting on those words or phrases and any others that come to mind, what do you hope to get out of this study?

Watch Session One Video (21 MINUTES)

Leader, stream the video (streaming instructions can be found inside the front cover from this guide) or play the DVD.

As you watch, take notes while thinking through:

WHAT CAUGHT YOUR ATTENTION?

WHAT SURPRISED YOU?

WHAT MADE YOU REFLECT?

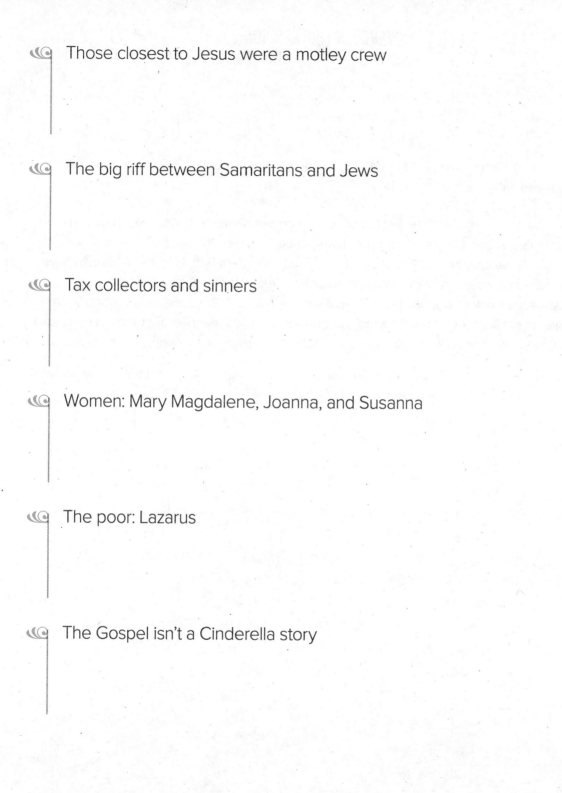

Those closest to Jesus were a motley crew

The big riff between Samaritans and Jews

Tax collectors and sinners

Women: Mary Magdalene, Joanna, and Susanna

The poor: Lazarus

The Gospel isn't a Cinderella story

SCRIPTURE COVERED IN THIS SESSION:
LUKE 8:1-3, LUKE 16:19-31, LUKE 18:9-14

Group Discussion Questions (30-45 MINUTES)

Leader, read each numbered prompt and question to the group and select volunteers for Scripture reading.

1. We begin our study of the Gospel of Luke in an overview. This allows us to understand the magnitude of context in this book and in each of the Gospel accounts. Lisa said, "Luke is the only known Gentile or non-Jewish author of Scripture. In that era, to have a non-Jew write a religious book, especially one of the Gospels, was like having a barbecue truck at a vegan festival. That's just a big deal. Because Luke probably felt like an outsider, he gears his writing to show how Jesus reached out to the outliers and outcasts like the Samaritans, the tax collectors and sinners, the women, and the poor."

 Describe a time when a person went out of their way to reach out and make you feel seen, included, and loved. How did the encounter impact you?

 "None of the other Gospel writers include **Samaritans** as much as Luke did. They were considered **outliers**—the worst kind of **traitors** since they had chucked everything the Orthodox Jews held sacred to the curb. By the time you get to the first century and the early life and ministry of Jesus Christ, the **enmity** between Jews and Samaritans **ran** so **deep** that Jews would pray **curses** on Samaritans when they went to Temple. Yet **Jesus** seeking out the Samaritans and equipping them as evangelists **demonstrates** His deep **compassion**." — Lisa

What kinds of people do you tend to judge, hold at arm's length, or look down on?

Why does Jesus make a beeline toward the Samaritans and extend unconditional love?

Who do you relate to more in this scenario? The Samaritans or the Orthodox Jews? Have you considered your relationship with each?

Who do you see as having more contempt for the other? If the Jews knew of the Messiah and his value, why do you think they would have not wanted to share him with those who did not? Have you ever been there? Holding onto something as if it were only yours and others were not worthy of it too?

2. Select a few volunteers to split reading the passage Luke 16:19–31. Ask the following questions regarding the passage:

How does the wealthy man treat the beggar?

How does Jesus show compassion toward the beggar?

How does Jesus challenge the wealthy man to consider his sinful posture?

How does Jesus equally love all sinners?

Samaritans were considered **outliers** —the worst kind of

traitors

since they had **chucked** everything the **Orthodox** Jews held sacred

to the curb.

3. Go around the group answering a selection of the following questions:

> Take a moment to consider the invisible people in your daily life—those you pass by and subtly overlook or simply don't consider. Who are they?

> What changes do you need to make to truly see and engage them?

Close in Prayer

Consider the following prompts as you pray together for:

- Eyes to see Jesus' acknowledgment of the likes of me

- Ears to hear the response to my unspoken needs

- Opportunities to engage outliers and outcasts just like Jesus

Preparation

To prepare for the next group session:

1. **Read Luke 1–2.**

2. Tackle the three days of the Session One Personal Study.

3. Memorize this week's passage using the Beautiful Word Scripture memory coloring page. As a bonus, look up the Scripture memory passage in different translations and take note of the variations.

4. If you've agreed to bring something for the next session's Opening Group Activity, get it ready.

WHEN OUTLIERS, OUTCASTS, AND THE UNLOVELY STEP INTO THE EMBRACE OF KING JESUS, THEY BECOME BEAUTIFUL.

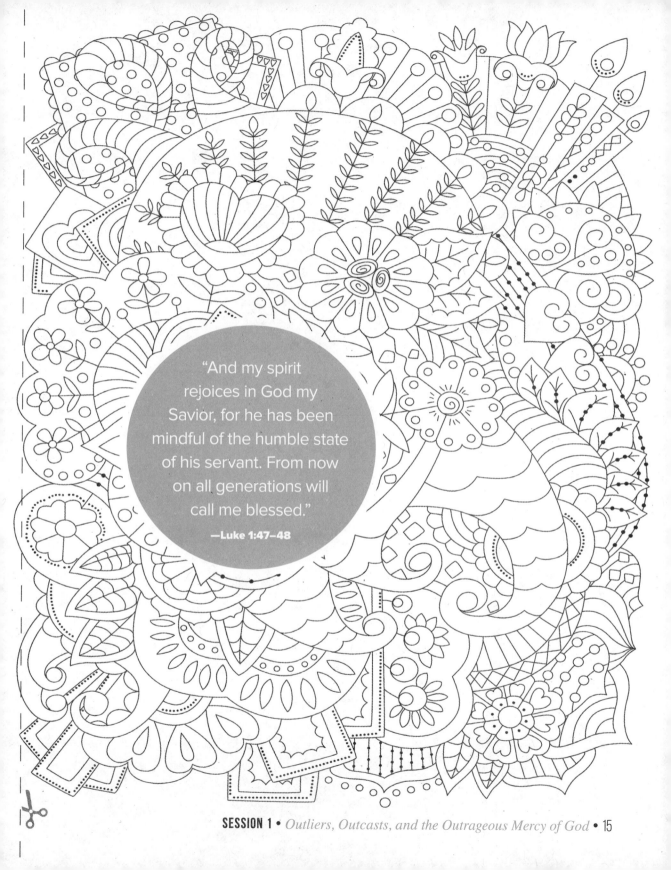

"And my spirit rejoices in God my Savior, for he has been mindful of the humble state of his servant. From now on all generations will call me blessed."

—Luke 1:47–48

PERSONAL
STUDY TIME

DIGGING INTO THE

Beautiful
WORD™
BIBLE STUDIES

Luke

OUTLIERS, OUTCASTS, AND THE OUTRAGEOUS MERCY OF GOD

Day 1
Luke 1:1-25

Gospel means "good news." Of the four Gospels, Matthew, Mark, Luke, and John, Luke highlights the outrageous mercy of God most. From the opening verses, we see compassion and tender care on display as God is working in and through the lives of those who feel left behind, forgotten, invisible, and rejected. Jesus readily goes to those on the margins to scoop them up in his mercy and love.

Luke doesn't want anyone left out of the deep wells of Jesus' compassion. He addresses his letter to Theophilus, also addressed in Acts 1:1, but it's meant for all of us. Some scholars believe the name, Theophilus, is a generic title that applies to all Christians, but it's more likely that Luke is writing to a specific person. The description "most excellent" suggests he may have been a high-ranking Roman official, and therefore an outsider as a non–Jew.

1. **Read Luke 1:1–4. How do Luke's opening words show that he wants Theophilus and his readers to know and experience the presence of Jesus and his compassion?**

Theophilus means

"LOVED BY GOD"

and carries the idea of "friend of God."

—LUKE 1:3

In the ancient world, women who had children were celebrated as being blessed, but those unable to have children were often judged as having done something wrong and lacking the favor of God.

Zechariah and Elizabeth both gave their whole hearts to God, yet still experienced a painful, unfulfilled desire in their life that left them feeling less than.

2. **Read Luke 1:5–7.** Consider how Zechariah and Elizabeth are described in this passage. What's one painful, unfulfilled desire in your life that's made you feel less than?

With thousands of priests in every division, the odds of Zechariah being selected for the great privilege of offering incense were highly unlikely. Zechariah's selection was a once-in-a-lifetime experience that only God could have timed to coincide with the news he was about to receive.

3. **Read Luke 1:8–25.** How does God reach out to Elizabeth and Zechariah, who had felt shame for their childlessness?

4. **How is Elizabeth blown away by the outrageous mercy of God (Hint: v. 25)?**

The entire book of Luke is jam-packed full of examples of people who are not seen or acknowledged, or are buried in shame, and God comes along and sees them.

5. Describe how the outrageous mercy of God changes your understanding of God—whether you're observing his mercy toward others, or you've experienced it yourself.

Day 2
Luke 1:26-38

Pregnancy can be uncomfortable, isolating, and lonely. God knows this, and in his compassion, doesn't leave two women with surprise births alone. God gives Elizabeth a special companion: her younger cousin, Mary.

Now, Mary's situation is a mess by cultural standards. Though betrothed, or promised to be the wife of Joseph, she miraculously becomes pregnant through the Holy Spirit. And while the immaculate conception reveals that she is highly favored by God, the surrounding community would still view her with disdain. In antiquity, an unwed mother became the center of gossip, speculation, and scandal, shunned by her community.

1. **Read Luke 1:26–33.** In the chart below, compare what the angel said to Mary about her child and what the angel said about Zechariah about his child.

READ LUKE 1:29–33.	READ LUKE 1:13–17.
What details does the angel mention about Jesus?	What details does the angel mention about John?

What do Jesus and John share in common? How will their lives differ?

Eventually both men will grow up to become outsiders to the religious community.

Pause for just a moment and sit in this truth: God intentionally uses outsiders to change the world. We don't have to understand it fully to comprehend how God values people differently than we often do.

While Zechariah asks for a sign, Mary asks for understanding about how God will accomplish his promise. The angel tells Mary that the Holy Spirit will *episkiazo*—or "overshadow"—her. The presence of God, much like the cloud of the tabernacle, will make this possible. Then the angel encourages Mary that God's timing and power are greater than she can imagine.

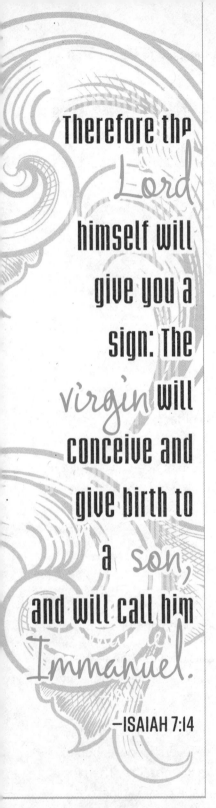

Therefore the *Lord* himself will give you a sign: The *virgin* will conceive and give birth to a *son,* and will call him *Immanuel.*

—ISAIAH 7:14

2. **Read Luke 1:34–37.** Consider Mary's circumstance of culture, tradition, her age, being unwed and pregnant. When life turns sideways and you're feeling isolated or like an outsider, why is it so important to know you're not alone?

3. **Read Luke 1:38.** How does Mary respond to the angel Gabriel's news?

How do you tend to respond when God prompts you to do something that might cause you to be seen as "less than" or somehow diminished in the eyes of others?

4. Is there an area of your life in which you presently feel prompted to give God a response like Mary's? What's stopping you from doing it?

Day 3
Luke 1:39–80

Some of the biggest outliers in first century culture were women. They were considered second-class citizens. Now, there were a few exceptions, like Deborah, who was effectively the prime minister of Israel in the Old Testament. But by and large, women were considered chattel, something a man could own. One of the more common rabbinic proverbs during the time of Luke was about the Torah—the first five books of the Old Testament. The saying was that it was better that the Torah be burned than read by a woman.

Women were rarely included in the teaching of Torah, much less any type of leadership roles in orthodox faith until Jesus. Luke highlights our Savior's inclusion of women into his inner circle and includes more stories about women than the other Gospel writers. Likely because as a Gentile, Luke wasn't as tightly bound by the traditional gender role templates of Judaism.

Here we are in the opening chapter of Luke's Gospel and who does he focus on? Two women and how God is going to use them mightily.

At the news of her cousin Elizabeth's miraculous pregnancy, Mary travels an estimated fifty to seventy miles to a town in Judea to see her. This was a long, hard trip for a pregnant woman, but the incredible news compelled her. Together, they are no longer isolated and alone: they are bound by their experiences and the compassion God had on them. When they meet, something happens that only God could orchestrate.

1. **Read Luke 1:39–45. Why is Mary blessed and Elizabeth favored?**

2. What blessings have you experienced from your faith and obedience to God even when it might break the mold?

Where are you being challenged to walk in greater faith and obedience to God?

Mary breaks out in a song known as "the Magnificat." The song contains a dozen Old Testament references that proclaim God's strength, power, and goodness. The song can be divided into four parts.

3. **Read Luke 1:46–55** and fill in the chart below noting the characteristics and actions of God that Mary proclaims. Circle ⬭ any verses that highlight God's love toward the outliers and outcasts.

DIVISION OF THE MAGNIFICAT	SCRIPTURE	WHAT THE PASSAGE REVEALS ABOUT GOD
Proclaims What God Has Done	Luke 1:46–48	

DIVISION OF THE MAGNIFICAT	SCRIPTURE	WHAT THE PASSAGE REVEALS ABOUT GOD
Proclaims Attributes of God	Luke 1:49–50	
Proclaims God's Reversal and Compassion Toward the Lowly	Luke 1:51–53	
Proclaims God's Mercy to His People	Luke 1:54–55	

Mary's frequent mentions of Old Testament passages suggest that she had a deep knowledge of the Bible. She knew God's Word as she prepared to give birth to the Word (John 1:1). And she knew God was famous for his "reversals," when he draws close to those on the margins and upends those who are filled with pride.

Then Luke notes an important detail about Elizabeth and Mary's journey.

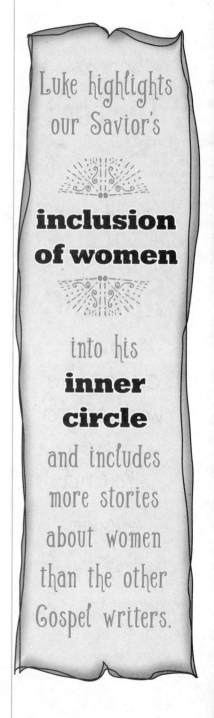

Luke highlights our Savior's

inclusion of women

into his **inner circle** and includes more stories about women than the other Gospel writers.

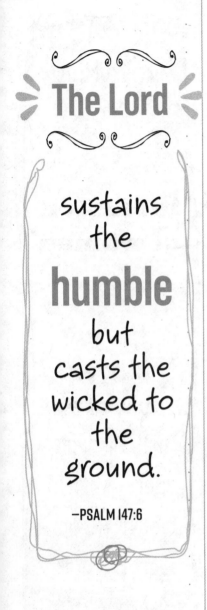

The Lord

sustains
the

humble

but
casts the
wicked to
the
ground.

—PSALM 147:6

4. **Read Luke 1:56.** Who is someone who has "stayed" with you during a difficult, uncertain, or confusing season?

How did your relationship deepen through that experience?

Who is someone you have "stayed" with during a difficult, uncertain, or confusing season? How did your relationship and visceral compassion for the other person grow and deepen through that experience?

Throughout the first chapter of Luke, the word "joy" appears quite often. When Elizabeth gives birth, the joy is shared through the entire community.

5. **Read Luke 1:57–66. How does Elizabeth giving birth to John fulfill the promises of Gabriel?**

What are the first words Zechariah speaks since the encounter with the angel (v. 64)?

Describe a time when you were able to offer a similar response to Zechariah after a time of hardship or suffering.

It was customary to name a child after the father or grandfather, so Elizabeth's objection was shocking to all who heard. In a culture where women were often dismissed and ignored, those watching turn to Zechariah to decide. Everyone is astonished when he writes the name John, meaning "graced by God."

Zechariah breaks out in a prophetic song that's known as "the Benedictus," which speaks of God's long-promised deliverance and the role John the Baptist will play in God's unfolding plan of messianic deliverance and salvation.

6. **Read Luke 1:67–80. How does Zechariah's song proclaim the outrageous mercy of God?**

Where do you need to experience this outrageous mercy most?

7. Read Luke 2 to prepare for the next session. Summarize what happens in this chapter in two to three sentences.

What do you love most in this story of Jesus' birth?

What challenges you most in this story of Jesus' birth?

Reflection

As you reflect on your personal study of Luke 1–2, what are the **BEAUTIFUL WORDS** the Holy Spirit has been highlighting to you through this time? Write or draw them in the space below:

SESSION 2

WORSHIP
IN THE
WAITING

Luke

Opening Group Activity (10–15 MINUTES)

WHAT YOU'LL NEED:

A music player (such as a smartphone) with a downloaded playlist so you are ready to play the popular Christmas song "Mary, Did You Know?" and pay attention to what characteristics of Jesus are mentioned.

1. Listen or sing along to the selected song. Consider printing out or providing a link to the lyrics.

2. Discuss the following questions:

 What do you think were the greatest struggles and joys of Mary as she raised Jesus?

 Which characteristics of Jesus in the song stood out to you most? Why?

 What does Jesus do to reach the outliers and outcasts in this song?

Watch Session Two Video (26 MINUTES)

Leader, stream the video or play the DVD.

As you watch, take notes while thinking through:

WHAT CAUGHT YOUR ATTENTION?

WHAT SURPRISED YOU?

WHAT MADE YOU REFLECT?

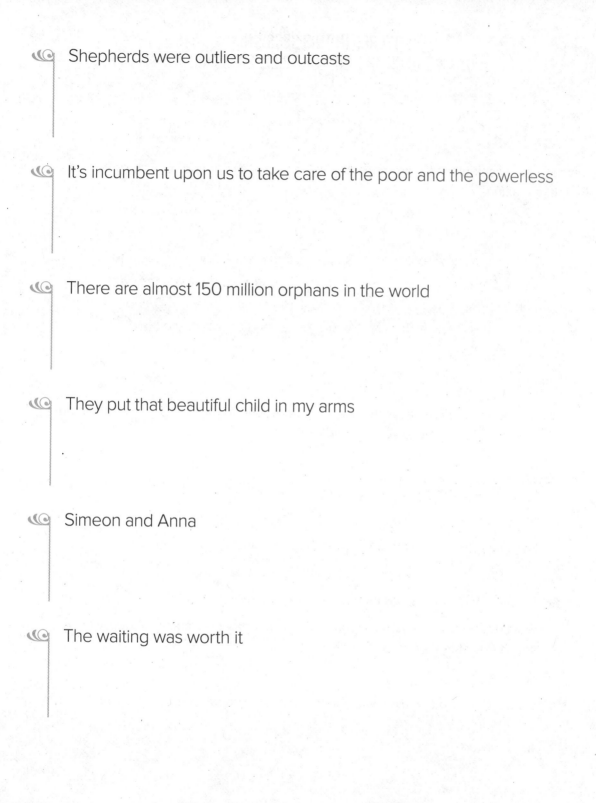

Shepherds were outliers and outcasts

It's incumbent upon us to take care of the poor and the powerless

There are almost 150 million orphans in the world

They put that beautiful child in my arms

Simeon and Anna

The waiting was worth it

SCRIPTURE
COVERED IN THIS SESSION:
LUKE 2:1-20, LUKE 2:22-33, 36-38

Group Discussion Questions (30-45 MINUTES)

Leader, read each numbered prompt and question to the group and select volunteers for Scripture reading.

> "Luke uses the word **'Savior'** eight times in his Gospel and nine times in the Acts of the Apostles. It's such a **tender** title—especially when we read, 'Today in the town of David a **Savior** has been born to you; he is the **Messiah**, the **Lord**' (Luke 2:8)." – Lisa

1. What does it say about Jesus that He would descend to earth as a vulnerable infant to demonstrate God's love to you and the world?

 What does the title of Savior mean to you personally?

 What has Jesus saved you from and what has Jesus saved you for?

2. **Read Luke 2:8–12 aloud** and then discuss the following.

 What does it reveal about the character of God that he would include lowly shepherds at the arrival of Jesus?

 Do you think God would invite you to something so spectacular? Why or why not?

If not, what prevents you from believing God would include you in something remarkable?

3. **Read Luke 2:25–32 aloud** or select a volunteer to read to the group. Then discuss a selection of the following questions:

Simeon was devout to God. Do you ever feel like your faith in God makes you feel like an outsider at work, everyday life, or even in the church? If so, describe.

What are you believing or holding on to hope for now that it seems everyone else has given up on?

How does Simeon's story encourage you in the waiting and in your faith?

Describe a time when the Holy Spirit prompted you to go somewhere or do something and good came from it.

4. **Leader, read Luke 2:36–38 aloud to the group.** Ask some of the following questions:

What makes Anna's faith and faithfulness so outrageous?

What did Anna practice during her years of waiting?

When you're in a season of waiting, what spiritual practices have been most helpful to you?

What would it look like for you to worship in the waiting?

IF WE
choose
TO WORSHIP
IN THE WAIT,
WHAT GOD
BRINGS US
IS EVEN
SWEETER.

Close in Prayer

Consider the following prompts as you pray together for:

- Courage to trust God with the details of life

- Patience in waiting for God to fulfill his promises

- An increased desire to worship

Preparation

To prepare for the next group session:

1. **Read Luke 3–4.**

2. Tackle the three days of the Session Two Personal Study.

3. Memorize this week's passage using the Beautiful Word Scripture memory coloring page. As a bonus, look up the Scripture memory passage in different translations and take note of the variations.

4. If you've agreed to bring something for the next session's Opening Group Activity, get it ready.

She never left the temple but worshiped night and day, fasting and praying (Luke 2:37).

PERSONAL
STUDY TIME

DIGGING INTO THE

Beautiful
WORD™
BIBLE STUDIES

Luke

WORSHIP IN THE WAITING

THE TOWN WHERE JESUS WAS BORN IS *Bethlehem,* MEANING *"house of bread,"* AND FULFILLS HE *prophecy* THAT THE MESSIAH WOULD BE *born* IN THIS *specific place* ACCORDING TO MICAH 5:2.

Luke is the only Gospel writer who links the arrival of Jesus to immediate historical and political events. Caesar Augustus had issued a tax collection notice that required registration. Joseph was forced to make a long journey with a very pregnant Mary. While Jews did not have to serve in the Roman army, they did have to pay taxes. The mighty Roman leadership and Cesar Augustus contrast sharply with a tiny infant born among livestock for whom generations have been waiting.

1. **Read Luke 2:1–7.** How does God use Caesar's decree to lead Joseph and Mary to the perfect place for Jesus' birth?

 What does this reveal about God's rule over earthly rulers?

2. How is Jesus' entrance into the world described? How does Jesus' entrance reveal that he, too, was an outlier and outcast? (Hint: v. 7)

How have your moments of feeling like an outlier and outcast given you greater compassion for those on the margins?

In keeping with the theme of Luke, shepherds were outliers partly because their jobs made them transient, which means they didn't have access to regular bathing, so they were a little unkempt and smelled like sheep.

Shepherds also had a well-deserved reputation for thievery. You might let a shepherd clean your barn, but you would not invite them to a dinner party. Yet God chose shepherds to be among the very first people who met the Messiah.

3. **Read Luke 2:8–15. What is the shepherds' (or earthly) response to the news of the Messiah's birth?**

4. What is the angels' (or heavenly) response to the news of the Messiah's birth?

How do the angels worship in the waiting?

The lowly shepherds became some of the first **evangelists** as they spread the news of Jesus' birth.

Luke 1:17

In the box below, draw a picture of what you imagine this scene looked like.

5. **Read Luke 2:16–21.** How does Mary respond to the strange things that are happening (Hint: v. 19)?

6. Take a moment to reflect on the power and position of Caesar Augustus and Jesus in Luke 2:1–21. How does Luke paint a picture of Jesus as an outlier among the poor and powerless by contrasting him to political leaders in the first two chapters?

Luke 2:22-52

According to the Old Testament, after a mother gave birth to a baby boy, she was considered ceremonially unclean for seven days. On the eighth day, the boy was to be circumcised. Then, she had to wait thirty-three days to be purified, for a total of forty days (Leviticus 12:1–4). The law also required that every firstborn be dedicated to God (Exodus 13:2). Joseph and Mary fulfill their duties as parents and followers of God.

1. **Read Luke 2:22–24.** How do Joseph and Mary demonstrate their high regard for Scripture and God through waiting and obedience?

At the end of 40 days of purification, a woman needed to make a sin offering of one lamb and either a dove or pigeon (Leviticus 12:6–8). If the family was poor, then they only needed to offer a pair of doves or pigeons. This is how we know that Mary and Joseph belonged to a low socioeconomic class (Luke 2:24).

Next, we meet two people who have been waiting on the promised Messiah and have their longings fulfilled in the temple.

2. **Read Luke 2:25–32.** What was Simeon waiting on because of the Holy Spirit?

What are three things you've waited on God for?

For each one, has it been worth the wait? Why or why not?

HE WILL
BE A HOLY
PLACE; FOR
BOTH ISRAEL
AND JUDAH
HE WILL BE A
STONE THAT
CAUSES PEOPLE
TO STUMBLE
AND A ROCK
THAT MAKES
THEM FALL.

ISAIAH 8:14

The Old and New Testaments give women the title of prophetess. Alongside Miriam, Deborah, and Hannah, Anna is described as holding this spiritual office. This remarkable woman was wholly devoted to worship and service in the temple.

3. **Read Luke 2:33–35.** What do you think Mary as a mother felt about Simeon's prophecy?

When has someone said something hard that ended up being a blessing to you?

4. **Read Luke 2:36–40.** What challenges you most about Anna's devotion to God?

In what area of your life would you most want to be like Anna?

In the space below, write a prayer asking for God to develop that quality in you.

Throughout the Gospels, little is mentioned of Jesus' childhood. But here we find one of the most compelling stories that reveals Jesus' spiritual development and leadership.

5. **Read Luke 2:41–52.** On the continuum below, how much do you think you would have responded like Mary to losing your child?

I would have
responded very
differently
than Mary

I would have
responded
just like Mary

What does Mary not understand about Jesus' purpose?

6. **Read Luke 2:40 and Luke 2:52.** What details are given about Jesus' childhood development?

Which of these characteristics do you most desire now? Why?

Day 3
Luke 3

Like in chapter two, Luke once again grounds us in the political and historical background. But this time, Luke is setting the stage for Jesus' forerunner, John the Baptist. Like many Old Testament prophets, Luke links John's ministry to the king's reign and affirms his ancestry to his father, Zechariah, who served as a priest.

1. **Read Luke 3:1–9.** How would you describe the tone and approach of John the Baptist's preaching?

 What do you like about what John the Baptist says?

 What is hardest for you to hear or accept?

2. **Read Luke 3:10–14.** What three things does John the Baptist instruct the crowds to do? Who are his instructions addressed to? Fill in the chart below.

WHO DOES JOHN THE BAPTIST ADDRESS?	SCRIPTURE	WHAT DOES JOHN THE BAPTIST INSTRUCT?
	Luke 3:10–11	
	Luke 3:12–13	
	Luke 3:14	

3. Reflecting on the chart on the previous page, why do you think the call to repent looks different in different people's lives?

How is God calling you to repent and change your ways?

4. **Read Luke 3:15–20.** How does John the Baptist continually shine the spotlight on Jesus?

How did Herod respond to John the Baptist's call to repent?

Do you feel like John the Baptist was properly rewarded for being faithful and obedient to God? Why or why not?

Have you ever thought that if you're faithful and obedient to God, nothing bad will ever happen?

How does John the Baptist's story challenge that kind of thinking?

Jesus' public ministry begins with his baptism. Luke describes the Holy Spirit descending on Jesus in the physical form of a dove. The imagery of the dove is reminiscent of the Spirit hovering over the waters in Genesis 1:2 as well as the return of the dove to Noah following the flood (Genesis 8:8–12). The voice from heaven affirms Jesus' identity as God's Son.

5. **Read Luke 3:21–22. Write the words of the voice in the space below.**

Why do you think God, the Father, affirmed Jesus, the Son, *before* his ministry started?

Where do you most struggle to believe in God's affirmation and approval of you?

While Matthew's genealogy begins with Abraham, Luke traces Jesus' lineage all the way back to Adam. Both are called the "son of God." This tells us Jesus came to save all of humanity.

6. **Read Luke 3:23–38.** Which names in the genealogy do you recognize?

What does it tell us about Jesus that Adam, Abraham, and David are mentioned?

7. **Read Luke 4** to prepare for the next session. Summarize what happens in this chapter in 2 to 3 sentences.

What stands out to you about the opposition Jesus faced?

What stands out to you about the miracles Jesus performed?

Reflection

As you reflect on your personal study of Luke 2–4, what are the BEAUTIFUL WORDS the Holy Spirit has been highlighting to you through this time? Write or draw them in the space below:

UPHILL
GLORY

 Opening Group Activity (10-15 MINUTES)

WHAT YOU'LL NEED:

Five different items that will be used for a 'guess the price' game. Make sure you know the cost of each one. Consider using an assortment of food, clothing, jewelry, artwork, or home decor. If possible, choose items that are much more and much less expensive than one might think.

Pens
Small cards that denote each item as one through five
One sheet of paper for each person
Small prizes (optional)

1. Place the numbered items where everyone in the group can see them. Then invite participants to play a game of guessing the cost of each item.

2. Invite everyone to share their guesses and track how close they were from the actual cost. Consider giving a prize to the person who is closest overall to the correct total cost. Then discuss the following questions:

 Which items' prices were easiest to guess? Why?

 Which items' prices were hardest to guess? Why?

 When you think about your life, do you tend to overestimate or underestimate what things will cost you in time, energy, and emotion? Explain.

Watch Session Three Video [29 MINUTES]

Leader, stream the video or play the DVD.

As you watch, take notes while thinking through:

WHAT CAUGHT YOUR ATTENTION? ▶ WHAT SURPRISED YOU?
▶ WHAT MADE YOU REFLECT?

All addictions are ultimately a disorder of worship

We wanted the adventure, but we hadn't counted the cost

Intimacy with Jesus comes at a cost

Jesus in the wilderness

Jesus reading and fulfilling Isaiah's prophecy

Bull riding

SCRIPTURE COVERED IN THIS SESSION:
LUKE 4:1-28

Group Discussion Questions (30-45 MINUTES)

Leader, read each numbered prompt and question to the group and select volunteers for Scripture reading.

> "If you don't put Jesus in the **biggest hole** in your soul, you'll be **drawn** to the **wrong** people. You'll be drawn to the wrong **things**, wrong **substances**. You're just looking for the **unconditional love** that God wired you for." – Lisa

1. When have you used something other than Jesus to fill the huge hole in your soul?

 What was the result?

 In what way are you struggling with this now?

> "I think in this postmodern time of being Christians, we've forgotten the **cost** of being a Christ **follower**. We were never meant to **trend** or to **blend**." – Lisa

2. Have you really considered what it costs you to be a Christ follower?

What does the cost of following Jesus look like in your daily life?

3. Lisa told the story of Thérèse of Lisieux, along with other women, who paid a high price for their devotion. They would devote themselves to a church and live in an annex built on the side of the church that had no door and only a small window. They would be given last rites, and then they would live in that small room for the rest of their lives, their sole purpose being to pray that the people who attended that sanctuary would know Jesus. They sacrificed their very lives and their futures. Most of them died very young because it's unhealthy to live in a tight box.

What challenges you most about their devotion?

What would it look like for you to live a more devoted life to Christ?

What has God nudged you to do that you've resisted because it will be hard?

4. **Read Luke 4:1–13 aloud or select a volunteer to read to the group.** Then discuss a selection of the following questions:

Describe a time when you transitioned from one of the highs of life or ministry to one of the dark depths. How did you handle the transition?

If you don't put Jesus in the biggest

hole in your soul,

you'll be drawn to the wrong people and places.

Do you tend to feel closer to God when you're in an abundant season of life or a painful, hard season? Discuss why.

What does Jesus use to overcome the wily ways of the enemy?

What helps you resist temptation?

5. Go around the group answering a selection of the following questions. This is the experience of uphill glory:

What do you love more than Jesus?

What are you more preoccupied with than Jesus?

What are you willing to give up to be closer to Jesus?

How are you modeling your life after Jesus as one who came to serve rather than be served?

Close in Prayer

Consider the following prompts as you pray together for:

- Grace to count the cost of following Jesus

- Strength to finish the race of faith well

- Courage to make greater sacrifices for Christ

Preparation

To prepare for the next group session:

1. **Read Luke 4:1–7:15.**

2. Tackle the three days of the Session Three Personal Study.

3. Memorize this week's passage using the Beautiful Word Scripture memory coloring page. As a bonus, look up the Scripture memory passage in different translations and take note of the variations.

4. If you've agreed to bring something for the next session's Opening Group Activity, get it ready.

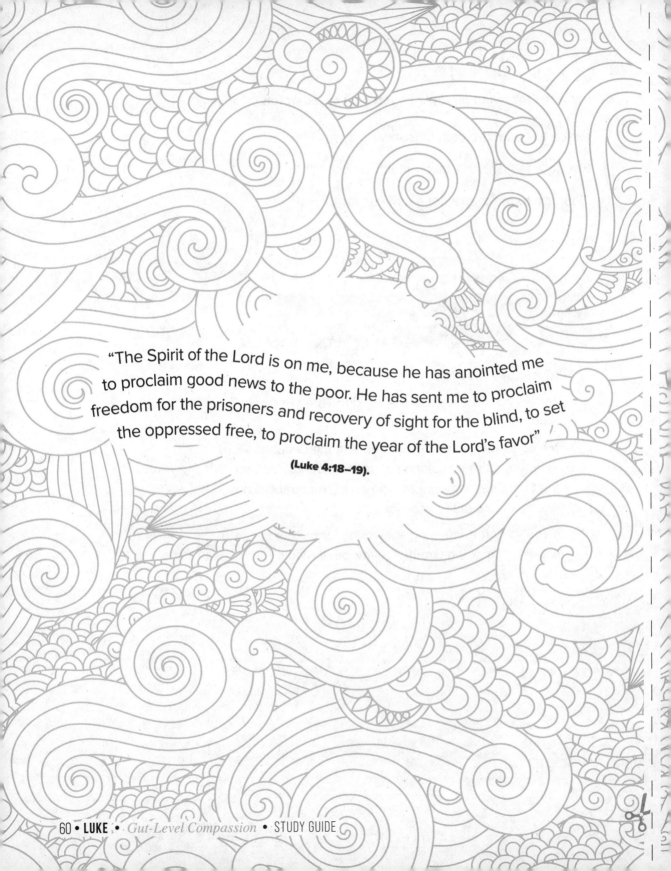

"The Spirit of the Lord is on me, because he has anointed me to proclaim good news to the poor. He has sent me to proclaim freedom for the prisoners and recovery of sight for the blind, to set the oppressed free, to proclaim the year of the Lord's favor"

(Luke 4:18–19).

SESSION

3

PERSONAL
STUDY TIME

DIGGING INTO THE

Beautiful
WORD
BIBLE STUDIES

Luke

UPHILL GLORY

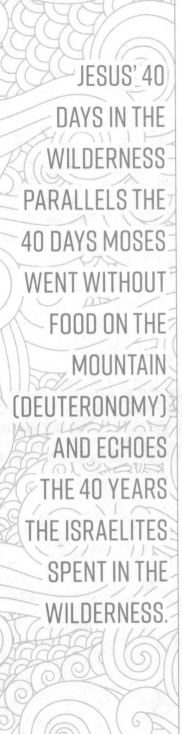

JESUS' 40
DAYS IN THE
WILDERNESS
PARALLELS THE
40 DAYS MOSES
WENT WITHOUT
FOOD ON THE
MOUNTAIN
(DEUTERONOMY)
AND ECHOES
THE 40 YEARS
THE ISRAELITES
SPENT IN THE
WILDERNESS.

Day **1**
Luke 4:1-30

After Jesus' remarkable baptism, the Spirit leads him into the wilderness. Sometimes it's tempting to think that the Spirit only leads us to delightful, life–giving places, but Jesus' story reminds us that sometimes the Spirit will lead us into hard, difficult situations so that we may overcome evil and radiate God's goodness and glory.

1. **Read Luke 4:1–13.** What are the specific temptations of the devil and how does Jesus respond? Fill in the chart below.

WHAT IS THE DEVIL'S TEMPTATION?	SCRIPTURE	HOW DOES JESUS RESPOND TO THE TEMPTATION?
	Luke **4:3–4**	
	Luke **4:6–8**	
	Luke **4:9–12**	

2. The devil tempts Jesus with provision, power, and proving himself. Which of these temptations do you tend to struggle with the most? Why?

How do you overcome that temptation?

3. Why does the devil wait for an opportune time to tempt Jesus (v. 13)?

Which of the following situations are opportune times for the enemy to tempt you? Circle ⬭ all that apply.

When I haven't slept When I'm hungry

When I don't forgive quickly When I look when I shouldn't

When I overfill my schedule When I don't set healthy boundaries

Other _____

What can you do to avoid these temptation triggers?

The year of the Lord's favor

(Luke 4:19)

is reflective of the year of Jubilee

(Leviticus 25:8-17).

Once every 50 years, slaves were freed and debts were forgiven, reversing the effects of sin and a fallen world.

After his time in the wilderness, Jesus returns to Galilee, and once again Luke notes that the Holy Spirit is working through him. Yet a pattern soon emerges whereby Jesus shares the good news, and the Jewish leaders reject the message, and Jesus casts a wider net to the non-Jews, the outsiders.

4. **Read Luke 4:14–29.** How do the listeners change their response to Jesus' claim that He is the fulfillment of Isaiah's prophecy?

How does Jesus highlighting that Elijah was sent to help a non-Jewish widow and Elisha to heal a leper demonstrate God's compassion for the outlier and outcast?

5. Why does reaching the outlier and outcast make people so angry?

Have you ever been on the receiving side of this kind of anger? If so, describe.

6. **Read Luke 4:30.** Describe a time when you experienced God making a way for you when there was no way.

Where do you most need God to make a way in what feels like an impossible situation?

Jesus shares the good news, and the Jewish leaders reject the message, and

JESUS CASTS A WIDER NET

to the non-Jews, the outsiders.

Day 2
Luke 4:31–44

The crowds grew furious with Jesus in the temple, but now their response changes to astonishment. They can tell Jesus doesn't teach like the other rabbis—he has a different authority. As Jesus moves forward in ministry, a spiritual war is taking place with the forces of darkness. Evil spirits who are unclean contrast sharply with a holy God. Demonic confrontation becomes a regular part of Jesus' healings.

1. **Read Luke 4:31–37.** What does Jesus do?

How do Jesus' actions demonstrate and fulfill what he declared in vv. 18–21?

Jesus rebukes the evil spirit and demands silence (4:35). This reveals Jesus' absolute authority over evil as well as recognition by the evil spirits that Jesus was coming to destroy them.

2. How does casting out an impure spirit demonstrate Jesus' visceral compassion to those in need?

3. Reflecting on what you've read so far, do you think there's anyone who Jesus would refuse to love and liberate? Explain.

4. How can you live more open-hearted to seeing, loving, and engaging those who are different from you?

The crowds can tell Jesus doesn't teach like the other rabbis— he has a **different** authority.

Jesus heals many through his travels, but now his healing power becomes personal to Simon Peter, whose mother-in-law has become seriously ill.

5. **Read Luke 4:38–44.** How does Jesus respond to Simon Peter's mother-in-law?

How does Simon's mother-in-law respond to being healed?

In what area of your life do you long to experience the deep healing of Jesus?

6. Write a prayer in the space below asking for healing.

 Day 3
Luke 5:1–11

Jesus could have called high-ranking religious leaders, scribes, or scholars as his disciples. Instead, he calls a ragamuffin group of fishermen and tax collectors to follow him. At every turn, Jesus is upending the world's understanding of power and success as he demonstrates the remarkable realities of the kingdom of God.

1. **Read Luke 5:1–5.** Why does Jesus' request of Simon seem absurd?

Why did Simon obey?

How did Simon demonstrate faith before he encountered the power of Jesus?

JESUS' TEACHING ON A BOAT ALLOWED HIS MESSAGE TO REACH MORE PEOPLE AS HIS VOICE REFLECTED OFF THE WATERS.

LUKE USES THE WORD "SINNER" FIFTEEN TIMES IN HIS GOSPEL, USING A TONE OF COMPASSION (V. 8). IT'S OFTEN USED TO DESCRIBE THOSE WHO ARE OUTSIDE THE RELIGIOUS CIRCLE AND YET ARE OBJECTS OF DIVINE GRACE THROUGH JESUS.

The miracle Jesus performs is unique in that while it's a miracle of provision, the provision isn't to meet immediate physical needs but rather to demonstrate the power of the kingdom of God.

2. **Read Luke 5:6–9.** What is Simon's response to the miracle?

3. Would you describe this as a miracle of provision or a demonstration of the kingdom of God—or both? Explain.

4. **Read Luke 5:10–11.** What does it reveal about Jesus that he would use fishing terminology to communicate the calling on Simon's life?

In what unique ways has God ever communicated with you?

5. What blessings have you experienced from your uphill walk of obedience to God?

6. Where are you being challenged to walk in greater faith and obedience to God?

7. Read Luke 5:12–7:15 to prepare for the next session. Summarize what happens in these chapters in two to three sentences.

How is Jesus' ministry expanding in these chapters?

At every turn, Jesus is **UPENDING** the world's understanding of **POWER** and **SUCCESS** as he demonstrates the remarkable realities of the **KINGDOM** of God.

What's the most challenging statement Jesus makes in these chapters for you personally?

Reflection

As you reflect on your personal study of 4:1–7:15, what are the
BEAUTIFUL WORDS the Holy Spirit has been highlighting to you
through this time? Write or draw them in the space below:

SESSION 4

GUT-LEVEL
COMPASSION

Opening Group Activity (10-15 MINUTES)

WHAT YOU'LL NEED:

A music player (such as a smartphone) with a downloaded playlist so you are ready to play a song that speaks of Jesus as the compassion of Christ such as "Everyone Needs Compassion."

1. Listen or sing along to the selected song. Consider printing out or providing a link to the lyrics.
2. Discuss the following questions:

 Which lyrics are the most meaningful to you now? Why?

 Is there anyone in your life who you think doesn't need compassion? Why?

 How are compassion and salvation interwoven?

Watch Session Four Video (27 MINUTES)

Leader, stream the video or play the DVD.

As you watch, take notes while thinking through:

WHAT CAUGHT YOUR ATTENTION?
WHAT SURPRISED YOU?
WHAT MADE YOU REFLECT?

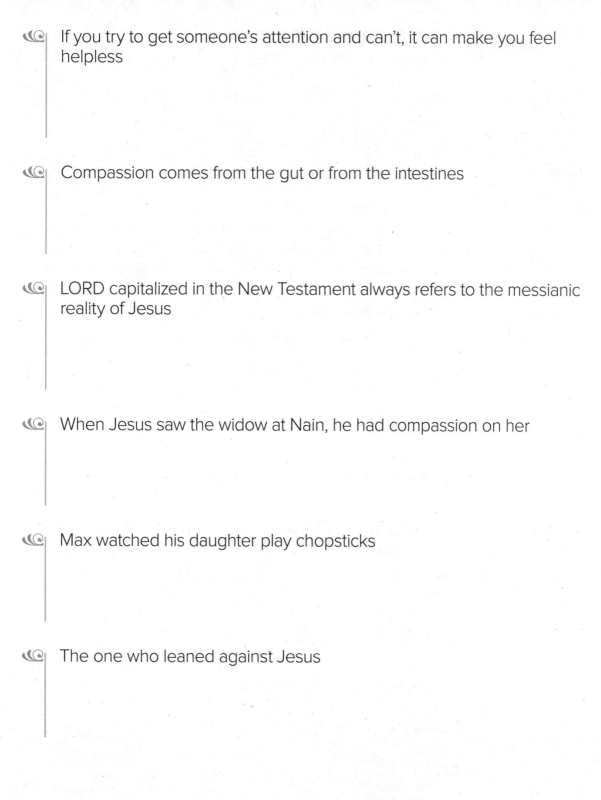

If you try to get someone's attention and can't, it can make you feel helpless

Compassion comes from the gut or from the intestines

LORD capitalized in the New Testament always refers to the messianic reality of Jesus

When Jesus saw the widow at Nain, he had compassion on her

Max watched his daughter play chopsticks

The one who leaned against Jesus

SCRIPTURE COVERED IN THIS SESSION:
LUKE 5:12-13, LUKE 7:11-15

Group Discussion Questions (30-45 MINUTES)

Leader, read each numbered prompt and question to the group and select volunteers for Scripture reading.

1. Lisa tells the story of being injured in the back of a pick-up truck and desperately trying to get her parents' attention. They didn't notice her, and they couldn't hear her. It made her feel so helpless. Lisa's counselor said the most common denominator of those who come to her office is people who feel like they've been missed or people who feel like they've been hurt and nobody sees them.

 Describe a time when you've been missed, needed help, or been hurt and no one saw you.

 What did you think or feel?

 How did that experience help you develop gut-level compassion toward others?

2. **Select two volunteers to split reading Luke 5:12–13 and Mark 1:40–41.** Ask some of the following questions regarding the passage:

 What stands out to you most about the man with leprosy?

 What stands out to you most about the way Jesus responds to him?

 When have you experienced God seeing or hearing your cries?

What's the cry of your heart that you most want God to respond to now?

> "Jesus **reaches** out and he **holds** the man, and then he **heals** the man. Look at the chronology. While that man is still **filthy, disfigured, stinky, repugnant,** and contagious, Jesus holds and heals him of his physical disease. Jesus knew that man's heart was infinitely **more diseased** than his body." — Lisa

3. In what ways are you tempted to believe you have to be all cleaned up or perfect before Jesus holds and heals you?

Which of the following do you need more: for Jesus to hold you or for Jesus to heal you? Discuss.

> "At the end of his Gospel account, John didn't say who he had **studied under**. He didn't say how many churches he had **planted**. He said, 'I'm the one who **leaned against** Jesus's chest.'" — Lisa

What does it look like for you to lean against Jesus' chest? Describe the circumstance and why leaning into Jesus is/ was the most important response.

While we are still filthy, disfigured, stinky, repugnant, and contagious, Jesus holds and heals us of our disease.

MOVED BY DEEP, VISCERAL COMPASSION, JESUS WILL ALWAYS CLOSE THE GAP BETWEEN US AND HIM.

4. Go around the group answering a selection of the following questions:

> Who is someone you're challenged to show gut-level compassion toward?

> Who are you holding at arm's length because you're waiting for them to get all cleaned up or become perfect before you show them gut-level compassion?

> How do the teaching and passages today challenge you to change your response?

Close in Prayer

Consider the following prompts as you pray together for:

- Courage to lean against Jesus' chest

- Faith to believe Jesus sees and hears us always

- Opportunities to demonstrate gut-level compassion to others

Preparation

To prepare for the next group session:

1. **Read Luke 5:12–10:37.**

2. Tackle the three days of the Session Four Personal Study.

3. Memorize this week's passage using the Beautiful Word Scripture memory coloring page. As a bonus, look up the Scripture memory passage in different translations and take note of the variations.

4. If you've agreed to bring something for the next session's Opening Group Activity, get it ready.

LORD capitalized in the New Testament always refers to the messianic reality of Jesus.

When the Lord saw her, his heart went out to her and he said, "Don't cry."

(Luke 7:13)

PERSONAL STUDY TIME

DIGGING INTO THE

Beautiful WORD™ BIBLE STUDIES

Luke

GUT-LEVEL COMPASSION

Day 1
Luke 5:12–6:49

Jesus continues healing and embracing people that most had dismissed and pushed to the furthest margins of society. In the process, Jesus upends the religious rules and laws that had prevented followers from fulfilling the commands to love God and love others.

1. **Read Luke 5:12–26.** What do these two healings have in common?

Who are the roof-raising people in your life who bring you closer to Jesus?

Why does Jesus offer the paralytic man forgiveness before healing?

Tax collectors were also called "Publicans," because they took from the public for the government. Many would mark up the taxes, then they would give what was due to Rome and keep the rest for themselves. Once again, Jesus embraces those whom others rejected and despised.

2. **Read Luke 5:27–39.** Do you consider yourself among the healthy or the sick? Explain.

What is Jesus' mission statement (vv. 31–32)?

How does Jesus' mission statement compare to your own?

What changes do you need to make so your mission statement is more like Jesus'?

Would you describe yourself as drinking from the old or new wineskin? Explain.

The confrontation between Jesus and the religious leaders continues to grow throughout the Gospel of Luke. Jesus' authority and actions reveal the disparity between the Kingdom of God and the rules of the religious leaders.

3. **Read Luke 6:1–11.** How would you describe the power struggle between Jesus and the religious leaders?

Where do you see that kind of power struggle taking place today?

Where have you allowed legalism to get in the way of demonstrating gut-level compassion toward others?

4. **Read Luke 6:12–19. What stands out to you about the way Jesus prepared for the selection of the disciples and the ministry that followed?**

How do you discern the people you're supposed to reach out to and embrace?

One of Jesus' most famous sermons is known as the Sermon on the Mount (Matthew 5–7). After Jesus calls His disciples, he descends with them to level ground (Luke 6:17) and soon delivers the Sermon on the Plain or the Sermon on the Platea. It contains numerous parallels to the Sermon on the Mount. Some scholars believe it's the same event, but others believe Jesus likely taught the same sermon on different occasions in different places like itinerant ministers today.

5. **Read Luke 6:20–45. List five principles of Christ-centered living from this passage.**

1. _____

2. _____

3. _____

4. _____

5. _____

WHILE THE GOSPEL OF MATTHEW'S SERMON ON THE MOUNT OFFERS THE BEATITUDES, THE GOSPEL OF LUKE FRAMES THEM IN THE NEGATIVE AS A SERIES OF WOES.

THE GREEK WORD FOR **hypocrite** (LUKE 6:42) WAS OFTEN USED TO DESCRIBE AN **actor** IN A DRAMA OR SOMEONE WHO PRETENDED TO BE WHAT THEY WERE NOT.

Which of these is easiest for you to follow and obey? Why?

Which of these is hardest for you to follow and obey? Why?

6. **Read Luke 6:46–49.** How does following the ways and teachings of Christ lead to a life built on the rock?

Consider the following two commands of Jesus. Circle the one that is most challenging.

Hears the Word **Acts on the Word**

In the space below, write a prayer asking God to help you obey Jesus' commands.

Day 2
Luke 7–8

Following the Sermon on the Plain, Jesus then demonstrates what these principles look like through his actions, interactions, and healing. Jesus calls us to be hearers and doers of God's Word, and Jesus is at the forefront of hearing and acting on God's Word. Through his healings, Jesus continues to demonstrate the gut-level compassion and inclusiveness of the kingdom of God.

1. **Read Luke 7:1–17.** How were each of these characters outliers or outcasts to the Jewish community?

How did Jesus respond to both?

How would you sum up the central message Luke communicates in this passage?

Despite all the miracles and healings, John the Baptist still questioned Jesus' messiahship. Discouraged and imprisoned, he had heard reports of Jesus' authority and power and wanted to know for sure for himself.

HE SENT
OUT HIS
WORD
AND

healed

THEM; HE
RESCUED
THEM
FROM THE
GRAVE.

PSALM 107:20

2. **Read Luke 7:18–35.** What questions does John the Baptist ask (v. 20)?

What do you think caused John the Baptist to question, doubt, or second-guess?

How does Jesus respond?

Based on this, how does Jesus respond to your questions, doubts, and second-guessing?

3. **Read Luke 7:36–50.** What does it look like for you to break your alabaster jar and offer up what is most valuable to Jesus?

When was the last time you did this?

What was the outcome?

When have you been dismissed or picked on for your vibrant love of Jesus?

Jesus upended social norms by including and featuring women throughout his earthly ministry. They played roles as financial backers and evangelists. They had front row seats to many of his miracles and listened to his many teachings, including the parables.

4. **Read Luke 8:1–15.** Fill in the chart below, observing the outcome of the seed in the various soils and Jesus' explanation of what they represent.

TYPE OF SOIL FOR THE SEED	OUTCOME OF THE SEED IN THE SOIL (LUKE 8:5–8)	EXPLANATION OF JESUS (LUKE 8:11–15)
Scattered along the path		
Rocky ground		
Among the thorns		
Good soil		

What kind of soil best represents your heart toward God, the Bible, and prayer? Explain.

5. **Read Luke 8:16–25.** What does Jesus' teaching and power reveal about who he is and the kingdom of God in this passage?

6. **Read Luke 8:26–39.** If you could ask Jesus one question about this story, what would you ask?

How does this passage illustrate Jesus' commitment to bring healing and wholeness to the very people others fear?

7. **Read Luke 8:40–55.** What do the stories of these two women have in common?

How do they differ?

A legion of Roman soldiers was around **6,000** men, so **Luke 8:30** suggests there were **many demons.**

When are you tempted to believe that if God works in another person's life, then he can't work in yours? How can you flip that script and see God's willing presence in your life?

Day 3
Luke 9–10

Jesus' ministry transitions as he sends out the disciples with the authority and power to do what they have seen their rabbi do. When they return, they are called apostles (Luke 9:10).

1. **Read Luke 9:1–11** and pay attention to Jesus' instructions and commands as you fill in the chart below.

SCRIPTURE	JESUS' SPECIFIC INSTRUCTIONS
Luke **9:2**	
Luke **9:3**	
Luke **9:4–5**	

Which of Jesus' specific instructions would be easiest for you to follow? Which would be hardest for you to follow? Why?

What was Jesus developing within his disciples through these instructions?

Jesus' feeding of the five thousand is the only miracle that appears in all four Gospels (other than the resurrection). Jesus demonstrates his power over creation and the source of our sustenance. Soon after, Peter asks a critical question.

2. **Read Luke 9:12–20.** What have been the rewards of giving your life to Jesus?

How would you answer Jesus' question, "Who do you say I am?"

> After two days he will revive us; on the third day he will restore us, that we may live in his presence.
>
> HOSEA 6:2

3. **Read Luke 9:21–27.** How does Jesus' teaching challenge some of the current teachings that are in the church today?

What roles have sacrifice and suffering played in your spiritual journey?

> Jesus' feeding of the five thousand is the only miracle that appears in ALL four Gospels (other than the resurrection).

Gathered with Peter, James, and John, the veil over Jesus is lifted so his three closest disciples see him more clearly. This moment is known as the "transfiguration," which comes from the word "metamorphosis."

Two of the greats of the Old Testament, Moses and Elijah, appear with Jesus in "glorious splendor." This breathtaking scene gives the disciples hope and courage for the difficult days that are soon to come.

4. **Read Luke 9:28–42.** How does Jesus break the box of expectations during the transfiguration?

How would you describe Peter's response to the situation in one word?

How would you have responded?

Why do you think Luke places the story of the disciples' inability to free the boy directly after the transfiguration (vv. 37–42)?

What does this reveal about the correlation between faith and miraculous moments?

5. **Read Luke 9:43–10:24.** What are the top three lessons this passage reveals about the true nature of discipleship?

1. _____

2. _____

3. _____

Which of these is most challenging for you? Why?

What differences do you see between the sending out of the 72 (Luke 10:1–24) and the sending out of the 12 (Luke 9:1–10)?

6. On the continuum below, do you sense you're moving forward or pulling back in your discipleship to Jesus?

❶ ← ❷ — ❸ — ❹ — ❺ — ❻ — ❼ — ❽ — ❾ → ❿

I'm pulling back
in my discipleship

I'm moving forward
in my discipleship

In the space below, write a prayer asking God to remove anything that's holding you back from fully following Jesus.

7. **Read Luke 10:25–37** to prepare for the next session. Summarize what happens in this passage in two to three sentences.

What is the most powerful detail to you about the 72 being sent out?

What challenges you most about the Good Samaritan?

GATHERED WITH PETER, JAMES AND JOHN, THE VEIL OVER JESUS IS LIFTED SO HIS THREE CLOSEST DISCIPLES SEE HIM MORE CLEARLY. THIS MOMENT IS KNOWN AS THE "TRANSFIGURATION," WHICH COMES FROM THE WORD "METAMORPHOSIS."

Reflection

As you reflect on your personal study of Luke 5:12–10:37, what are the BEAUTIFUL WORDS the Holy Spirit has been highlighting to you through this time? Write or draw them in the space below:

THE TENDER HEART OF OBEDIENCE

Luke

Opening Group Activity (10-15 MINUTES)

WHAT YOU'LL NEED:

One sheet of blank colored paper for each person
Pens or markers
Scissors

1. Invite participants to share scissors and use them to cut out a large heart. Then ask each person to write a letter of affection, appreciation, or love to Jesus.

2. Discuss the following questions:

 What makes you most appreciative about Jesus?

 Which sentence in your letter best describes your heart toward Jesus now?

 How safe do you feel in giving your whole heart and affection to Jesus?

Watch Session Five Video (32 MINUTES)

Leader, stream the video or play the DVD.

As you watch, take notes while thinking through:

WHAT CAUGHT YOUR ATTENTION?
WHAT SURPRISED YOU?
WHAT MADE YOU REFLECT?

It's about being head over heels in love with Jesus

Rails around the top of your roof

Kim's mom and her exuberant love

Parables both conceal and reveal

The Good Samaritan

Riding a motorcycle with Missy

SCRIPTURE COVERED IN THIS SESSION:
LUKE 10:25-37

Group Discussion Questions (30-45 MINUTES)

Leader, read each numbered prompt and question to the group and select volunteers for Scripture reading.

> "Any text **without** a context is a **pretext** for a proof text. If you're ever around a Christian—or someone who claims to be a Christian—and they use God's Word as a **club** to hammer people or to beat **shame** into people, they're taking the passage out of **context**. At its core, the Bible is a **love** story. It's not a **rulebook**. It's not a **textbook**. It's not a collection of **benign** morality **tales**." — Lisa

1. Describe a time when you've experienced the Bible as a hammer or had it used to beat shame into you.

 Describe a time when *you've* used the Bible as a hammer or used to beat shame into yourself.

 When you're reading the Bible, what helps you experience it as a love letter?

2. **Select three volunteers to split reading Luke 10:25–37 to the group.** Then discuss a selection of the following questions:

 Like the lawyer who isn't content with Jesus' initial answer, how are you tempted to look for loopholes to God's ways?

What does it look like for you to go and do likewise (v. 37)?

3. Discuss the following:

When you find someone in crisis, do you tend to avoid the messiness altogether, are you among those who show up immediately but temporarily, or those who stay for the long haul? Discuss.

Who do you struggle to show tender mercy toward?

"**O**bedience is the fruit of **gratitude**. If we get what Jesus has done for us, we will be **compelled** to love the people in **ditches** around us and become more like the **Samaritan** than those caught up in **legalism**." — Lisa

4. Do you tend to serve and obey Jesus out of a sense of duty or delight?

What does it look like for you to be head over heals in love with Jesus?

What areas of your life feel more like a checklist than an expression of overwhelming gratitude? Where do you need the Holy Spirit to tenderize your heart?

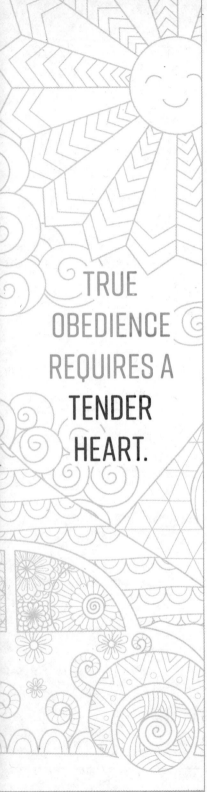

TRUE OBEDIENCE REQUIRES A TENDER HEART.

Close in Prayer

Consider the following prompts as you pray together for:

- Tender hearts

- Passionate love and affection for Jesus

- Overflowing mercy and kindness for others

Preparation

To prepare for the next group session:

1. **Read Luke 10:25–13:17.**

2. Tackle the three days of the Session Five Personal Study.

3. Memorize this week's passage using the Beautiful Word Scripture memory coloring page. As a bonus, look up the Scripture memory passage in different translations and take note of the variations.

4. If you've agreed to bring something for the next session's Opening Group Activity, get it ready.

"Go and do likewise"

(Luke 10:37).

PERSONAL STUDY TIME

DIGGING INTO THE

Beautiful
WORD™

BIBLE STUDIES

Luke

THE TENDER HEART OF OBEDIENCE

Day 1
Luke 10:25-42

While there are thousands of parables in rabbinic literature, only around forty parables are recorded throughout the Gospels—and twenty-eight of them appear in the Gospel of Luke. Jesus often used parables to describe the realities of the kingdom of God. Many of the parables incited the religious leaders and caused them to turn against him because they were so radical in nature. One of the most famous parables is the Good Samaritan.

1. **Read Luke 10:25–37. What should our life priorities be according to Jesus? (Hint: v. 27)**

2. **Read Deuteronomy 6:5 and Leviticus 19:18. Why do you think this is the greatest commandment?**

How does the greatest commandment breed tenderness in our hearts when obeyed?

"Parables both conceal and reveal. If you have a heart and ear as a seeker who wants to know the truth, they are revelatory."

–Lisa

3. Can you think of a commandment or call to obedience by Jesus that falls outside of this command? If so, explain.

4. When it comes to loving God, which of the following is easiest and most challenging for you? Rank the following in order of ease.

_____ Heart

_____ Soul

_____ Strength

_____ Mind

How does Jesus use each of these to make you more like him?

Following Jesus' parable and call to loving service, a tussle between Mary and Martha emerges that demonstrates the different ways people show their affection and conflict that can result.

5. **Read Luke 10:38–42.** Who is heralded as opening her home to Jesus?

The road to Jericho was isolated, rocky, and famous for robbers and bandits hiding and attacking those who passed by.

How did Martha express her devotion to Jesus?

How did Mary express her devotion to Jesus?

Why do you think Martha went to Jesus instead of Mary to express her concern?

6. Do you tend to express your devotion more like Mary or Martha? Explain.

Why do you think God wired you that way?

How are both expressions of devotion honoring to God if done with the right attitude?

Day **2**
Luke 11

Jesus' life and ministry were saturated with prayer. He regularly withdrew to spend time with the Father and often emerged with miraculous power over evil. The disciples take notice and now ask Jesus to teach them to pray.

1. **Read Luke 11:1–13. How does the Lord's prayer center you on God and redirect your priorities?**

What is Jesus teaching by using the word "us" throughout the prayer instead of "I"?

How does this prayer pull you away from self-centered living?

Beelzebul

is derived from the Canaanite god known as **Baal.**

Second Kings 1:2 Mentions The Name Baal-Zebub. This Means "Lord Of The Flies."

On the continuum below, how much do you believe God will give you what you ask?

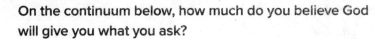

It's hard for me to believe

I believe with 100% confidence

What stops you from fully believing God will do what you ask?

How does Jesus challenge your thinking?

The tension between Jesus and the religious leaders continues to escalate as Jesus performs miracles and teaches of the kingdom of God in its power.

2. **Read Luke 11:14–28.** How does Jesus driving out a demon demonstrate in power what he just taught?

What did some people think gave Jesus his power and how did he correct them?

Despite Jesus' mighty miracles, some listeners still press him for a sign from heaven. Rather than perform a miracle on demand, Jesus reminds them of Jonah. Jonah delivered one of the shortest and yet most impactful sermons in history, leading to the Ninevites believing in God and turning from their wicked ways (Jonah 3:4–5). The book of Jonah ends with God correcting Jonah for his lack of compassion for those who don't know God.

3. **Read Luke 11:29–32. How does Jesus tell the people they are missing the point?**

When have you been called to repent or respond to God and missed it?

The Queen of the South (11:31) is the Queen of Sheba, who traveled long distances to hear SOLOMON'S WISDOM. She's mentioned in 1 Kings 10 and 2 Chronicles 9.

In the ancient world, light and darkness were often used as symbols of good and evil. Jesus reveals himself as the light of the world (John 8:12) and compares the kingdom of God to a lamp that must shine for the world to see. And we are to take in that light!

4. **Read Luke 11:33–36.** **Are the religious leaders struggling with a lack of light or a lack of perception? Explain.**

Jesus doesn't hesitate to expose the darkness within the Pharisees. He points out their hypocrisy, inconsistencies, and corruption.

5. **Read Luke 11:37–54.** **As you read through the woes, take note of what actions, behaviors, and attitudes Jesus rejects, as well as any calls to action Jesus instructs. Fill in the chart below.**

SCRIPTURE	ACTION JESUS REJECTS	ACTION JESUS INSTRUCTS
Luke **11:39–41**		
Luke **11:42**		
Luke **11:43**		

SCRIPTURE	ACTION JESUS REJECTS	ACTION JESUS INSTRUCTS
Luke **11:44**		
Luke **11:46**		
Luke **11:47–51**		
Luke **11:52**		

Why was Jesus so upset at the religious leaders?

How have any of their behaviors slipped into your life?

6. In the space below, write a prayer asking God to forgive you and free you from any ways your actions and attitudes are like those of the religious leaders.

Day 3
Luke 12:1–13:9

Jesus is reaching the height of his popularity, with people knocking into each other, trying to get closer to the rabbi. As his journey to Jerusalem for the Passover approaches, Jesus directs his teaching toward his precious disciples to prepare them for the tough days ahead.

1. **Read Luke 12:1–12.** What is worth fearing and what is not worth fearing according to Jesus?

How does Jesus promise to equip you when you're called to declare his truths?

Throughout Jesus' ministry, he used parables to reveal people's hearts and the mysteries of the kingdom of God. When someone asked a question about inheritance, Jesus responded by exposing the dangers of coveting and not recognizing that all things are merely gifts from God to be used for his glory.

2. **Read Luke 12:13–21. In what ways are you tempted to eat, drink, and be merry with your life?**

Where has greed crept in and hardened your heart?

3. **Read Luke 12:22–34. Where does worry tend to rise in your life and harden your heart? Circle all that apply.**

Health	Finances	Future
Relationships	Work	Daily life

THE HOLY SPIRIT AUTHENTICATES AND AFFIRMS THE TRUTH OF WHO JESUS IS. BLASPHEMING THE HOLY SPIRIT IS A FULL, UTTER, AND COMPLETE REJECTION OF THE SPIRIT'S REVELATION OF WHO JESUS IS AND ALL JESUS HAS DONE.

In the ancient world, LIGHT and DARKNESS were often used as symbols of GOOD and EVIL. Jesus reveals himself as the LIGHT of the world (John 8:12) and compares the kingdom of God to a LAMP that must SHINE for the world to see.

In the space below, write a prayer to cast all your cares on Jesus.

Jesus' challenge to steward material possessions well now transitions to being ready for his return.

4. **Read Luke 12:35–40.** What does it look like for you to do each of the following?

Be dressed and ready for service:

Keep your lamps burning:

Keep watch:

5. **Read Luke 12:41–13:8.** What does Jesus reveal about the following:

Watchfulness:

Division:

Discernment:

Repentance:

6. **Reflecting on Luke 10:25–13:9,** what are the key principles Jesus wants his disciples to know as he approaches the cross?

How are these principles crucial for today and for your life?

Jesus doesn't hesitate to expose the **DARKNESS** within the Pharisees. He points out their **HYPOCRISY, INCONSISTENCIES,** and **CORRUPTION.**

Throughout Jesus' ministry, he used parables to reveal **PEOPLE'S HEARTS** and the mysteries of the Kingdom of God.

7. **Read Luke 13:10–17** to prepare for the next session. Summarize what happens in this passage in two to three sentences.

Reflecting on what you've learned so far, what stands out to you about this healing?

What do you appreciate most about this story?

Reflection

As you reflect on your personal study of Luke 10:25–13:9, what are the BEAUTIFUL WORDS the Holy Spirit has been highlighting to you through this time? Write or draw them in the space below:

A BEAUTIFUL
UNBENDING

Opening Group Activity [10-15 MINUTES]

Go around your group and share one to two ways in which you are noticing a softening in your heart from this study so far.

Continue around the group sharing one to two areas where and in what ways you are still sensing a resistance to Jesus' visceral compassion. Simply name the areas of hesitation or questioning, no need to try to unravel them now. This is heart prep.

Watch Session Six Video [31 MINUTES]

Leader, stream the video or play the DVD.

As you watch, take notes while thinking through:

WHAT CAUGHT YOUR ATTENTION?
WHAT SURPRISED YOU?
WHAT MADE YOU REFLECT?

Community is how we see Jesus more clearly

She was sick and tired of being sick and tired

"Woman" is a term of endearment

We are never an interruption to Jesus

Conference in Colorado

Group Discussion Questions (30-45 MINUTES)

Leader, read each numbered prompt and question to the group and select volunteers for Scripture reading.

8. **Read Luke 13:10–13 aloud or select a volunteer to read to the group.** Then discuss a selection of the following questions:

 In what area do you feel bent over—physically, emotionally, or spiritually?

 Where are you most sick and tired of being sick and tired?

 What hope do you have that Jesus will heal you?

9. Discuss the following:

 When are you tempted to believe that you're interrupting Jesus—like your request or concern is too small or insignificant for God, or God has more important needs or people to attend to?

 How does this story challenge your thinking?

10. Go around the group and answer some of the following questions:

> Have you ever been tempted to look down on other women—in the church or outside of it—who are using their gifts? What compels this?

> How can you become a cheerleader of women?

11. **Read Luke 13:14–17**. Ask some of the following questions regarding the passage:

> How did the synagogue leader's response expose the hypocrisy of the religious leaders?

> When have you used religious rules to avoid loving someone and showing mercy?

> Why do you think the crowd responded the way they did?

12. Select different people from the group to read each of the following passages: **Psalm 139:13–14**, **Romans 8:1–2**, **John 15:16**, **1 Peter 2:9**, **Colossians 3:1–4**, **2 Corinthians 5:17**, and **Isaiah 43:1–4**.

> Go around the group and ask participants which scripture they need to be read and prayed over them. Then have a different participant prayerfully read the passage over that person.

YOU ARE NEVER AN *Interruption* TO JESUS— HE'S ALWAYS READY FOR A *beautiful* UNBENDING.

Close in Prayer

Consider the following prompts as you pray together for:

- A beautiful unbending through Jesus

- Personal experiences with God's unconditional love

- Confidence that you're never an interruption to God

Preparation

To prepare for the next group session:

1. **Read Luke 13:18–15:32; 22:39–62.**

2. Tackle the three days of the Session Six Personal Study.

3. Memorize this week's passage using the Beautiful Word Scripture memory coloring page. As a bonus, look up the Scripture memory passage in different translations and take note of the variations.

4. If you've agreed to bring something for the next session's Opening Group Activity, get it ready.

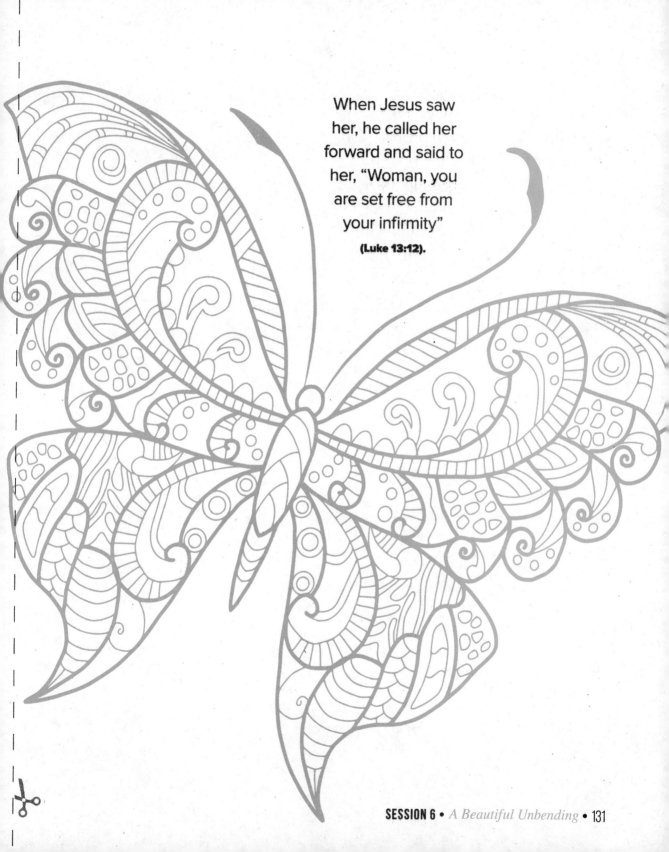

When Jesus saw her, he called her forward and said to her, "Woman, you are set free from your infirmity" (Luke 13:12).

PERSONAL STUDY TIME

DIGGING INTO THE

Beautiful
WORD™
BIBLE STUDIES

Luke

A BEAUTIFUL UNBENDING

Day ① Luke 13:18–14:35

After healing the woman who had been bent over for eighteen years, Jesus tells a pair of parables that illustrate God's power and the reality of God's kingdom. Jesus uses a mustard seed, which can grow into a tree over ten feet in height, and yeast to show how that which is tiny can be mighty and effective in God's kingdom.

1. **Read Luke 13:18–21.** How is the kingdom of God like each of the following?

 Mustard Seed:

 Yeast:

 How have you seen God use something tiny to do expansive work in his kingdom?

Jesus emphasizes the importance of repentance and participating in the kingdom of God as well as his tender care for Jerusalem and his journey there. The word "Jerusalem" appears three times in Luke 13:33–35 to emphasize Jesus' compassion and care.

2. **Read Luke 13:22–35. How have you experienced the door to the kingdom of God as wide open?**

How have you experienced the door to the kingdom of God as narrow?

In your words, how would you describe Jesus' gut-level compassion toward Jerusalem?

Jesus' teachings and ministry often took place around a table. Once again, we find Jesus gathered with others—this time with a prominent Pharisee. Through parables and teachings, Jesus once again demonstrates that the kingdom of God embraces the outliers and marginalized.

3. **Read Luke 14:1–13. How are the Pharisees leveraging the law to avoid practicing compassion toward the outliers and unclean?**

When have you used religious rules to avoid getting involved in someone else's messy life?

Why is it better to invite those who are dismissed and discounted into your home and life than the upwardly mobile and famous?

What does Jesus promise as a reward?

Is this reward worth it to you? Why or why not?

Jesus continues the table discussion with a parable about a feast and how people respond to the invitation.

4. **Read Luke 14:15–24.** When did you last host a gathering or threw a party?

How did you determine who made it on the list and who was left off the list?

Consider how power dynamics, social compatibility, or previous interactions shaped who was included and who was excluded. How might you change your perspective in the future?

NO MAN
WHO HAS ANY
DEFECT MAY COME
NEAR: NO MAN
WHO IS BLIND OR
LAME, DISFIGURED
OR DEFORMED.

LEVITICUS 21:18

5. In Jesus' parable, what excuses are given to not attend the banquet?

Which of these excuses do you find yourself using or being distracted by in your relationship with God?

Luke 14 concludes with Jesus highlighting the **cost** of being a disciple. He urges those who want to follow him to be ready to **give up everything.**

Toward the end of the parable, who is invited and who is disinvited to the banquet?

What does this reveal about God's heart toward those who feel furthest from him?

Luke 14 concludes with Jesus highlighting the cost of being a disciple. He urges those who want to follow him to be ready to give up everything. Jesus uses hyperbole—some exaggeration—to emphasize his point. He isn't saying we should hate our relatives, but that our love for God should be so great that anything else in comparison feels like hate.

6. **Read Luke 14:25–35.** What does costly discipleship look like for your life?

Day 2
Luke 15:1–16:31

Some scholars have called this section of Luke the "Gospel of the Outcast," as Luke shows Jesus' care for those on the margins. Through the imagery of lost sheep, a lost coin, and a lost son, Jesus uses a trio of parables to reveal God's costly love for all. The climax of each story is the great rejoicing and celebration that follows each return.

1. **Read Luke 15:1–9.** How do each of these parables justify Jesus' embrace and celebration of sinners or outcasts?

It's no accident that immediately following two parables of celebration after finding that which was lost, there's the parable of the Lost Son or the Loving Father. The story contains vivid details and the emotions of each participant, making it one of the most beloved parables of all time.

2. **Read Luke 15:10–32** and reflect on the attitudes and actions displayed by each of the following:

The younger son:

The older son:

The loving father:

Who is more lost: the younger son who left home or the older son who never left home? Why?

As a father has compassion on his children, so the Lord has compassion on those who fear him.

PSALM 103:13

3. In what ways do you struggle with thinking or behaving like the younger son?

In what ways do you struggle with thinking or behaving like the older son?

In what ways do you struggle with thinking or behaving like the loving father?

4. In your relationships, who are you most likely to dismiss, discount, or shun because they're thinking or behaving like the younger son? The older brother? The loving father?

5. When have you missed out on a celebration because you judged or dismissed someone else?

6. What action or change in attitude is this parable asking of you?

In asking for his inheritance, the younger son was telling his father that he wishes his father was dead.

Day **3**

Luke 16

Jesus continues his discourse through teaching and parables that call listeners to costly discipleship. If chapter 15 looked at God's love for the lost, this is now contrasted with the dangers of power, wealth, and material possession. The Pharisees were known to be lovers of power and money, and Jesus challenges this with God's perspective.

1. **Read Luke 16:1–9. Some interpret this parable as a story of a dishonest manager and others as the story of a shrewd manager. How do you interpret this story? Why?**

2. **How have you seen power and wealth used to hurt and marginalize others?**

 How have you seen power and wealth used to include, protect, and uphold others?

> *Mammon in Aramaic refers not just to money but to worldly possessions of all kinds.*

3. **Read Luke 16:10–13** and reflect on how each verse calls you to faithfulness **and good use of** what you've been given. Fill in the chart below.

SCRIPTURE	CALL TO FAITHFULNESS AND GOOD STEWARDSHIP
Luke **16:10**	
Luke **16:11**	
Luke **16:12**	
Luke **16:13**	

What changes do you need to make in your attitudes or actions to worship **God with the wealth** you've been given?

Jesus didn't come to destroy the law but rather fulfill the law. Rather than view the Old Testament as cumbersome laws, Luke wants us to see that the promise of the law is fulfilled in Christ. The kingdom of God brings in a reversal whereby the humble become strong, the poor become wealthy, and the outcasts are intimate with God.

The parable of Lazarus illustrates God's justice when nothing on this side of heaven seems to make sense.

4. **Read Luke 16:16–31.** **How did the rich man spend his life?**

How did Lazarus spend his life?

Which person best represents how you're spending your life? Explain.

5. **What does it look like for you to spend time and energy on those who are overlooked, ignored, and suffering?**

6. How is your care of the poor an act of worship?

7. **Read Luke 22:39–62** to prepare for the next session. Summarize what happens in this passage in two to three sentences.

In what ways do you think you would have responded like Peter?

How would your responses to the situation have differed from Peter's?

The parable of Lazarus illustrates GOD'S JUSTICE when NOTHING on this side of heaven seems to make SENSE.

Reflection

As you reflect on your personal study of Luke 22:39–62, what are the BEAUTIFUL WORDS the Holy Spirit has been highlighting to you through this time? Write or draw them in the space below:

SESSION 7

A MOST RADICAL RESTORATION

Opening Group Activity (10-15 MINUTES)

WHAT YOU'LL NEED:

Sticky notes
Pens
A nearby wall, window, or flat surface

1. Give participants one to three sticky notes and invite each person to reflect on something that broke, was lost, or was taken, but that God has restored.

2. Invite each participant to write a word of thanks for that which God has restored.

3. Place their sticky note prayers on a nearby wall, window, or flat surface in such a way that, together, all the sticky notes form the shape of a cross.

4. Discuss the following questions:

 What's something in your life that broke, was lost, or was taken from you that you've seen God restore in some way?

 What's something in your life that you're still waiting on God to restore or repurpose?

 What advice do you have for someone who is still waiting for God to do a restorative work in their life?

Watch Session Seven Video (31 MINUTES)

Leader, stream the video or play the DVD.

As you watch, take notes while thinking through:

WHAT CAUGHT YOUR ATTENTION?

WHAT SURPRISED YOU?

WHAT MADE YOU REFLECT?

Go into the deep and do a little more fishing

Lazarus comes back to life

The man who takes up his mat

Peter's epic failure

The restoration of Peter

The South African widow who forgave and loved

SCRIPTURE covered in this session:
LUKE 5:1-11; 22:39-62

Group Discussion Questions [30-45 MINUTES]

Leader, read each numbered prompt and question to the group and select volunteers for Scripture reading.

> "I don't do that many things well—I'm kind of a jack of a few trades, master of **none**. I'll tell you, there's one thing I do well, and that's **gratitude**, because Jesus has **rescued** me from so many **pits** I've **dug** myself. Jesus has **redeemed** my story. Jesus has **restored** unto me decades first served up to **locusts** on a silver platter." – Lisa

1. What's the most profound restoration God has done in your life?

 What did that experience help you realize about God?

 How did that experience impact how you trust God with your future?

2. **Select a few volunteers to split reading the passage Luke 5:1–11.** Ask the following questions regarding the passages:

 What stands out to you most about this passage? Why?

 What surprises you most about Peter's response?

 When have you been gripped by the knowledge of your sinful nature and unworthiness before a holy God?

3. Discuss the following:

How does this miracle open the door for Simon Peter to enter a new stage in his relationship with Jesus?

What miracles has God done in your life?

How has God used them to transform you and your relationship with Jesus?

"After three full years of **being** with Jesus, **talking** with Jesus, **eating** with Jesus, Peter **drops** the ball. One morning he proclaims with passion that he'll **never betray** Jesus, and by the end of evening, Peter doesn't just betray Jesus once, but **three times** vehemently and vulgarly. He's a **hot mess**." – Lisa

4. Have you ever done anything that you really regret that affected your relationship with God?

How did you experience God's forgiveness, grace, and restoration?

Explain which was easier for you—forgiving yourself or experiencing God's forgiveness.

5. **Select a few volunteers to split reading the passage John 21:1–19.** Ask the following questions regarding the passages:

How does Peter respond to the news that it's Jesus?

When you've done something you regret, do you tend to run toward Jesus or hang back? Explain.

What does Jesus' radical restoration of Peter reveal about the ways Jesus responds to you?

6. Go around the group answering a selection of the following questions:

In what ways are you still clinging to the lie that you must be perfect and never mess up to receive Jesus' gut-level compassion?

What's stopping you from receiving Jesus' lavish love and grace?

Who do you most need to demonstrate Jesus' gut-level compassion toward even though they've messed up?

Close in Prayer

Consider the following prompts as you pray together for:

- Receptivity to the lavish love and grace of Jesus

- Awareness of the depths of God's forgiving embrace

- Restoration in every area of life

Preparation

To prepare for the next group session:

1. **Read Luke 17:1–22:34.**

2. Tackle the three days of the Session Seven Personal Study.

3. Memorize this week's passage using the Beautiful Word Scripture memory coloring page. As a bonus, look up the Scripture memory passage in different translations and take note of the variations.

4. If you've agreed to bring something for the next session's Opening Group Activity, get it ready.

THE MOST *Radical* RESTORATIONS COME FROM **THE DEEP** Compassion OF CHRIST.

"Put out into deep water, and let down the nets for a catch."

(Luke 5:4)

PERSONAL
STUDY TIME

DIGGING INTO THE

Beautiful WORD™ BIBLE STUDIES

Luke

A MOST RADICAL RESTORATION

Day **1**

Luke 17-18

Jesus continues preparing His disciples for the days ahead by teaching them about faithfulness, trust, forgiveness, and the cost of discipleship. He blends parables with instruction to expose the religious insiders' rejection of the Gospel, while those who are considered outsiders embrace the Good News with joy and thankfulness.

1. **Read Luke 17:1–10.** What stumbling blocks can emerge when you become a religious insider?

How do these stumbling blocks create barriers to those who are on the outside?

Which of these stumbling blocks are you most tempted by?

What can you do to avoid them?

Once again showing his compassion toward those who are outliers, Jesus encounters ten people with leprosy. Only one returns with gratitude—and that person is a Samaritan.

2. **Read Luke 17:11–21. What is Jesus saying through this miracle about outsiders?**

What is Jesus saying through this miracle about radical restoration?

Jesus delivers a prophetic word regarding the Second Coming and the separation of good and evil.

3. **Read Luke 17:22–37. How does this passage challenge you to follow Jesus more intimately and intentionally?**

"Anyone with such a defiling disease must wear torn clothes, let their hair be unkempt, cover the lower part of their face and cry out, 'Unclean! Unclean!'"

Leviticus 13:45

Jesus has made it clear that no one knows when he will return, so he wants his disciples to know how to pray—and live—in an unjust world until then.

4. **Read Luke 18:1–8.** **How does Jesus once again show favor for the overlooked in this parable?**

What does it look like for you to demonstrate faith in an unjust world as you wait for Jesus' return?

PRIDE BRINGS A PERSON LOW, BUT THE LOWLY IN SPIRIT GAIN HONOR.

PROVERBS 29:23

Many of the parables and teachings of Jesus were shocking to those who heard them. He kept flipping common beliefs and systems upside down as he rebuked the arrogant, powerful, and self-righteous.

5. **Read Luke 18:9–34.** **Who are the outcasts and outliers that Jesus exalts and restores in this passage?**

Who are those struggling the most to embrace the ways, teaching, and life of Jesus?

What does this passage reveal to you about how to draw close to Jesus?

The gut-level compassion of Jesus is once again displayed when he encounters a man by the name of Bartimaeus who is blind. Those surrounding the man tell him to hush, but in an act of courageous defiance, Bartimaeus calls out even louder, "Son of David, have mercy on me!" (Luke 18:39).

6. **Read Luke 18:35–43.** **How does Jesus restore Bartimaeus physically and spiritually?**

What role do faith and action play in Bartimaeus' healing and radical restoration?

What role do faith and action play in your healing?

Day **2**
Luke 19–20

In Jesus' final interactions and teachings before his arrival in Jerusalem, he doesn't just reach another outcast—he reaches the chief of outcasts: the chief tax collector. Such a title suggests Zacchaeus not only used his authority to rob and steal but endorsed and taught his underlings to do the same.

To the Jewish people, Zacchaeus was a much-hated villain. Yet Jesus didn't hesitate to bring the Good News of the kingdom of God and deliver an invitation to salvation, transformation, and restoration.

1. **Read Luke 19:1–10. How does Jesus demonstrate extravagant compassion and grace?**

How does Zacchaeus demonstrate extravagant repentance?

How does Jesus restore Zacchaeus?

Write Luke 19:10 in the space below.

How has Jesus demonstrated and fulfilled this declaration in the last five chapters?

The cost of true discipleship continues to be at the forefront of Jesus' teachings. In the parable of ten minas (about thirty months wages), Jesus challenges disciples to practice the wise use of resources and humility before God. The parable also alludes that Jesus will not bring in the messianic leadership of Israel so many had hoped for, but rather his journey to Jerusalem will defy expectations.

2. **Read Luke 19:11–27.** What does this parable reveal about the kingdom of God?

What can be learned from the unfruitful servant who loses his mina (or three months wages) and the citizens who reject the king's rule?

MANY OF THE PARABLES AND TEACHINGS OF JESUS WERE **SHOCKING** TO THOSE WHO HEARD THEM. HE KEPT **FLIPPING** COMMON BELIEFS AND SYSTEMS **UPSIDE DOWN** AS HE REBUKED THE ARROGANT, POWERFUL, AND SELF-RIGHTEOUS.

What changes do you need to make to avoid these kinds of attitudes and actions?

REJOICE
GREATLY,
DAUGHTER ZION!
SHOUT, DAUGHTER
JERUSALEM! SEE,
YOUR KING COMES
TO YOU, RIGHTEOUS
AND VICTORIOUS,
LOWLY AND RIDING
ON A DONKEY, ON A
COLT, THE FOAL OF
A DONKEY.

ZECHARIAH 9:9

Jesus could have made a grand entrance into Jerusalem riding a golden chariot surrounded by legions of military. Instead, Jesus chooses a posture and attitude he's been teaching and embodying all along—one of humility. He selects a donkey colt (Matthew 21:7) that's never been ridden before. The animal was a symbol of peace and contrasts sharply with the horse ridden by warriors.

3. **Read Luke 19:28–48.** **What statements are being made through word and deed as Jesus enters Jerusalem?**

How do the insiders, the Pharisees, respond to what they see among the crowd?

How does Jesus demonstrate gut-level compassion toward Jerusalem?

Once Jesus enters Jerusalem, a series of controversies emerge over his authority and teaching. The religious rulers ask questions and raise issues to undermine Jesus, but his wisdom silences them. Yet the religious leaders refuse to give up and soon develop a plot to destroy Jesus.

4. **Read Luke 20:1–8.** How does Jesus outwit the scheming religious leaders?

5. **Read Luke 20:9–19.** How does Jesus' parable expose the controversy and the religious leaders' refusal to listen?

6. **Read Luke 20:20–40.** What are the concerns of the religious leaders and how does Jesus answer them? Fill in the chart below.

SCRIPTURE	RELIGIOUS LEADER'S CONCERN AND JESUS' ANSWER
Luke 20:20–26	
Luke 20:27–40	

The controversies end with Jesus challenging the religious leaders.

7. **Read Luke 20:41–47.** What is Jesus saying through the question he asks the religious leaders?

What does Jesus warn the religious leaders about doing?

Are there any of these that you're tempted by? If so, explain.

A SERIES OF CONTROVERSIES EMERGE OVER JESUS' AUTHORITY AND TEACHING. THE RELIGIOUS RULERS ASK QUESTIONS AND RAISE ISSUES TO UNDERMINE HIM, BUT HIS WISDOM SILENCES THEM.

Day 3

Luke 21:1–22:34

After Jesus exposes the greed of the religious leaders, He celebrates the outrageous generosity of a poverty-stricken widow. While many give out of their abundance, she mightily gives out of her lack and, in the process, this outlier is a hero in the kingdom of God.

1. **Read Luke 21:1–4. How does this woman demonstrate the principles of the kingdom of God through her actions?**

How does she challenge you to not look at others in the ways the world sees them?

Jesus delivers some hard news. The very temple that the people loved and celebrated, that had become a central focus of the nation, would soon be destroyed (it was destroyed in 70 A.D.).

2. **Read Luke 21:5–11. What warnings does Jesus give regarding the cataclysmic events to come?**

Have you ever been duped by someone who deceived you by claiming to be god–like or a super–Christian? If so, explain.

Have you ever been duped by someone who deceived you by claiming the time was near and caused you to live in fear or buy things you didn't need? If so, explain.

3. **Read Luke 21:12–19.** What does Jesus ask believers to do during these events?

Which of these is most challenging to you now?

The poverty-stricken widow mightily gives out of her lack and, in the process, this outlier is a hero in the Kingdom of God.

How does it comfort you to know that Jesus will give you everything you need to do what he's called you to do?

4. **Read Luke 21:20–28.** What does it look like for you to "stand up and lift up your heads" (v. 28) during great uncertainty and challenges?

5. **Read Luke 21:29–38.** In what ways have you allowed your heart to become weighed down or distracted?

What does it look like for you to stay alert and prayerful?

Even as Jesus' arrest grows near, he continues to teach in the temple during the day and retreat to the Mount of Olives at night. But behind the scenes, a betrayer lurks in the background.

6. **Read Luke 22:1–6.** What was the response of the religious leaders to Judas' offer?

When have you been sold out or betrayed by someone?

When have you sold someone out or betrayed someone else?

7. **Read Luke 22:7–38** to prepare for the next session. Summarize what happens in this passage in two to three sentences.

What do you appreciate most about the Last Supper?

What challenges you most in the Last Supper?

Reflection

As you reflect on your personal study of Luke 17:1–22:34, what are the BEAUTIFUL WORDS the Holy Spirit has been highlighting to you through this time? Write or draw them in the space below:

A TALE OF
TWO ROOMS

Luke

Opening Group Activity (10-15 MINUTES)

WHAT YOU'LL NEED:

Each person to bring food to share
Party balloons or fun decorations

1. Decorate the room with balloons, streamers, wildflowers, and anything else you can find to create a festive atmosphere.

2. Enjoy laughing, talking, sharing, and catching up as you eat together.

3. Discuss the following questions:

 What have you enjoyed most about the Gospel of Luke?

 What's one question or topic from the homework or discussion that really challenged you or stuck with you?

Watch Session Eight Video (31 MINUTES)

Leader, stream the video or play the DVD.

As you watch, take notes while thinking through:

WHAT CAUGHT YOUR ATTENTION?

WHAT SURPRISED YOU?

WHAT MADE YOU REFLECT?

Lisa Pablo

Passover and the Last Supper

First Upper Room

Jesus washes the disciples' feet

Second Upper Room

The cross happened

Let's take it to Samaria

SCRIPTURE covered in this session:
LUKE 22:7-34, ACTS 1:6-14

Group Discussion Questions (30-45 MINUTES)

Leader, read each numbered prompt and question to the group and select volunteers for Scripture reading.

> "Jesus says, 'I'm about to go to the **cross** where I'm going to be lifted up like a **common criminal,** because there's no way **sinful humans** can be **reconciled** to a holy God without my **sacrificial** blood. I want y'all to **remember** in the future, when you don't have **me** in the flesh, when you can't **touch** me, when you can't **see** me in the future, I want you to remember that I brought **my body** because you're **worth it** for me. I let them **pierce** my wrists and my feet because you're **worth it** to me. I let my **blood drain** out because **you're worth it** to me.'" – Lisa

1. How do you respond to Lisa's teaching that in all Jesus suffered he looks at you and says, "You're worth it to me!"?

 In what ways do you still struggle with accepting Jesus' unconditional love for you?

2. **Select a few volunteers to split reading the passage Luke 22:7–30.** Ask the following questions regarding the passages:

 What does it reveal about the disciples that after three years with Jesus that they're still fussing and jockeying for position?

What does this reveal about our own ability to lose sight of Jesus and the miracles he's done for us?

Where are you jockeying for position right now?

How does trying to "win" distract you from the wonders and presence of God?

"Christ loved **outliers** and **outcasts**, and perfection is not a prerequisite for a **relationship** with Jesus. The first **Upper Room** was defined by **pride;** it was defined by **division.** Considering their division, you'd think Jesus would have lectured them, but he doesn't. John tells us that Jesus **takes off** his outer robe, picks up a **towel,** effectively lays down his scepter in glory, and gets on his **knees** and begins to **wash all** their feet—even Judas' toes." — Lisa

3. How does Jesus' response to the disciples and their division challenge how you respond to division among believers?

Would you describe yourself as a division-bringer or a peacemaker? Why?

Whose feet do you need to wash through laying down your life and serving them?

4. **Select a few volunteers to take turns reading the passage Acts 1:6–14.** Ask the following questions regarding the passages:

> How do the attitudes and actions of the second Upper Room differ from the first Upper Room?

> How do the disciples and those gathered display unity?

> What attitudes, actions, and activities have you found spur unity among believers?

> What attitudes, actions, and activities have you found spur disunity among believers?

Discuss whether you're living more like the first Upper Room (Luke 22:12-20) or the second Upper Room (Acts 1:12-14) in your spiritual life and relationships.

"What happened in less than two months? What happened **from Passover to Pentecost?** The **cross** happened! Jesus' **compassion** was **personified** on the cross, and, if we **allow,** it will **change** our lives. And then, maybe **Samaria** would hear the Gospel and maybe the **outermost** parts of the world, maybe even just the **neighbors** across the street would hear what Luke has been proclaiming to **us** for eight weeks: he loves you; he loves you." – Lisa

5. How has the cross changed or impacted your life?

How does knowing and experiencing the depths of God's love empower you to share the depths of God's love with others?

How has the cross changed your view toward outsiders, outliers, and misfits?

6. Go around the group answering a selection of the following questions:

How have you experienced Jesus' gut-level compassion through your reading of the Gospel of Luke?

How would you sum up Jesus' heart toward the outsider, the outlier, and the outcast?

What's your biggest takeaway from this Beautiful Word study?

How may the Holy Spirit be empowering you to live differently because of this discovery?

Close in Prayer

Consider the following prompts as you pray together for:

- Unity among believers

- Gut-level compassion toward outliers, outsiders, and outcasts

- Gratitude for all God has done through this study

The compassion of Christ through the CROSS changes everything.

Preparation

1. **Read Luke 22:7–24:53**

2. Tackle the three days of Session Eight Personal Study.

3. Memorize this week's passage using the Beautiful Word Scripture memory coloring page. As a bonus, look up the Scripture memory passage in different translations and take note of the variations.

"The greatest among you should be like the youngest, and the one who rules like the one who serves" (Luke 22:26).

PERSONAL
STUDY TIME

DIGGING INTO THE

Beautiful
WORD™
BIBLE STUDIES

Luke

A TALE OF TWO ROOMS

When Jesus says, "That's enough" (22:38), regarding the two swords, He wasn't saying, "that was enough weaponry," but rather, "that is enough silly talk."

Day 1
Luke 22:7–23:56

During his final Passover with the disciples before his death, Jesus asks his followers to take the bread and the cup in remembrance of him. Though he's told them clearly multiple times of his impending death, they do not appear to have comprehended what lays ahead.

1. **Read Luke 22:7–38.** What are the strong emotions and opinions that emerge from the disciples during the Last Supper?

Which surprise or intrigue you the most?

How does Jesus respond to the disciples' division?

Like so many times before, Jesus returns to prayer. He agonizes with the Father over the suffering to come yet embraces the Father's will over his own. Soon after, Judas appears and betrays Jesus with a kiss.

2. **Read Luke 22:39–53.** How does Jesus' aloneness appear in this passage?

Describe how Jesus has now become the outcast and outlier.

Judas is often viewed as the disciple that betrayed Jesus, but Peter demonstrated a type of betrayal in disowning the One he promised to follow to the grave.

3. **Read Luke 22:54–62.** How does Peter's response intensify as Jesus asks more questions?

How does Peter respond to what he's done?

Have you ever felt this kind of remorse? Describe the circumstance.

In what tangible or spiritual ways did you encounter God through that time?

Jesus now stands trial before the Sanhedrin, Pilate, Herod, and the people. After a few rounds of political negotiation, Pilate surrenders Jesus to the will of the people. The crowds are given the choice between Barabbas, a criminal who stole from them, and Jesus, the Son of God who comes to redeem them.

4. **Read Luke 22:63–23:38.** What injustices does Jesus experience in this passage?

Describe the ways in which Jesus is dehumanized and treated as less than in this passage.

How does Jesus' response to such treatment challenge or convict you?

Even as the blood drains from his body and Jesus takes his final breaths, he still reaches out to the lowest of the low with gut-level compassion and the Good News of salvation.

5. **Read Luke 23:39–43.** How does this interaction between Jesus and two criminals affirm Jesus' teaching and message throughout his earthly ministry?

Reflecting on this story, is it ever too late for someone to experience the compassion of Christ? Why or why not?

6. **Read Luke 23:44–56.** Who are the main people in this passage and how does each one respond to the crucifixion of Jesus?

Which of these people best represents how you think you would have responded to witnessing Jesus' death? In what ways can you relate to their response?

THEREFORE, BROTHERS AND SISTERS, SINCE WE HAVE confidence TO ENTER THE MOST HOLY PLACE BY THE blood OF JESUS, BY A NEW AND LIVING WAY OPENED FOR US THROUGH THE CURTAIN, THAT IS, his body.

HEBREWS 10:19–20

Day 2
Luke 24:1–53

Luke concludes by providing multiple accounts of Jesus' resurrection appearance. Once again, Jesus shows his gut-level compassion toward the outlier by noting that the first people to discover the empty tomb were women. In the first century, women were not considered reliable witnesses, yet Jesus entrusts them with the greatest news of all time.

1. **Read Luke 24:1–12.** How do the women respond to:

 the empty tomb

 the angels

 their surprise discovery

 What was the first thing the women did after their experience at the tomb?

 What was the first thing you did when you realized Jesus conquered death?

In the first century, women were not considered reliable witnesses, yet Jesus entrusts them with the greatest news of all time.

Define "conquering death." What does that mean to you?

How did the disciples receive the women's story?

2. How often do you find yourself simply unable to accept the miraculous or the greatest thing or whatever because it is too hard to believe? What might cause you to dismiss the "too hard to believe" even when it's what you might need or want the most? Try to name the bias.

The story of the Road to Emmaus only appears in Luke's Gospel and demonstrates Jesus' readiness to enter his followers' disappointment and pain and reveal his presence.

3. **Read Luke 24:13–35.** Why can't the two disciples recognize Jesus?

4. What opens their eyes to the truth that Jesus is alive?

How does this moment connect to other similar moments with Jesus throughout Luke's Gospel?

When was the last time you were in a conversation when you found your heart "burning within you"?

Jesus now appears to the disciples. Despite knowing of Jesus' resurrection, they respond with shock and fear to his presence.

5. **Read Luke 24:36–49.** Why do the disciples have such a hard time believing Jesus has been resurrected?

"MOSES AND THE PROPHETS" is a term used to describe the ENTIRE Old Testament.

What do you still struggle to believe about Jesus?

How does Jesus demonstrate that he comes even for those who doubt and second-guess?

Luke's Gospel closes by depicting Jesus' ascension and setting us up for the Book of Acts by noting the disciples stayed together, continually at the temple praising God and waiting to be clothed with power as promised by Jesus (24:53).

6. **Read Luke 24:50–53.** What does the ascension of Jesus mean to you?

Consider and describe ways you are now, or might consider, spending your time as you wait for Jesus' return.

Day 3

Your Beautiful Word

Review your notes and responses throughout this study guide. Place a star by those that stand out to you. Then respond to the following questions.

1. **What are three of the most important truths you learned from studying the gut-level compassion of Jesus in Luke?**

 1. _____

 2. _____

 3. _____

 How have those truths set you free?

2. **After reviewing the eight Beautiful Word coloring pages, which scripture did you connect with the most? Why?**

3. What's one practical application from studying the gut-level compassion of Jesus that you've put into practice?

4. What's one practical application from the study that you would still like to put into practice?

5. How has the Holy Spirit prompted changes in your attitudes, actions, and behaviors because of studying the gut-level compassion of Jesus?

6. How has the Holy Spirit produced even more fruit in your life as you've reached out to those who are marginalized and outliers?

The disciples stayed together, continually at the temple

PRAISING GOD

and waiting to be clothed with power as **PROMISED** by Jesus.

Reflection

As you reflect on your personal study of Luke 22:35–24:53, what are the BEAUTIFUL WORDS the Holy Spirit has been highlighting to you through this time? Write or draw them in the space below:

SMALL GROUP LEADER'S GUIDE

If you are reading this, you have likely agreed to lead a group through *Luke: Gut-Level Compassion*. Thank you! What you have chosen to do is important, and much good fruit can come from studies like this. The rewards of being a leader are different from those participating, and we hope you find your own walk with Jesus deepened by this experience.

Luke is an eight-session study built around video content and small-group interaction. As the group leader, imagine yourself as the host of a dinner party. Your job is to take care of your guests by managing all the behind-the-scenes details so that as your guests arrive, they can focus on each other and on interaction around the topic.

As the group leader, your role is NOT to answer all the questions or reteach the content—the video, book, and study guide will do most of that work. Your job is to guide the experience and cultivate your small group into a kind of welcoming, teaching community. This will make it a place for members to process, question, reflect, and grow—not receive more instruction.

There are several elements in this leader's guide that will help you as you structure your study and reflection time, so follow along and take advantage of each one.

BEFORE YOU BEGIN

MATERIALS

Before your first meeting, make sure the participants have a copy of this study guide so they can follow along and have their answers written out ahead of time. Alternately, you can hand out the study guides at your first meeting and give the group members some time to look over the material and ask any preliminary questions. During your first meeting, be sure to send a sheet around the room and have the members write down their names, phone numbers, and email addresses so you can keep in touch with them during the week.

FREE VIDEO STREAMING ACCESS

Additionally, spend a few minutes going over how to access the FREE streaming video using the code printed on the inside front cover of each study guide. Helping everyone understand how accessible this material is will go a long way if anyone (including you) has to miss a meeting or if any member of your group chooses to lead a study after the conclusion of this one!

A few commonly asked questions and answers:

Do I have to subscribe to StudyGateway? NO. If you sign up for StudyGateway for the first time using **studygateway.com/redeem**, you will not be prompted to subscribe, then or after.

Do I set up another account if I do another study later? NO. The next time you do a HarperChristian Resources study with FREE streaming access, all you need to do is enter the new access code and the videos will be added to your account library.

There is a short video available, walking you through how to access your streaming videos. You can choose to show the video at your first meeting or simply direct your group to the HarperChristian Resources YouTube channel to watch it at their convenience.

HOW TO ACCESS FREE STREAMING VIDEOS: https://youtu.be/JPhG06ksOn8

GROUP SIZE

Generally, the ideal size for a group is between eight to ten people, which ensures everyone will have enough time to participate in discussions. If you have more people, you might want to break up the main group into smaller subgroups. Encourage those who show up at the first meeting to commit to attending the duration of the study, as this will help the group members get to know each other, create stability for the group, and help you know how to prepare each week.

OPENING ACTIVITY

Each of the sessions begins with an opening activity, which you, the leader, should read through and practice prior to your group meeting if it seems new to you.

There are a few questions that follow the activity which serve as an icebreaker to get the group members thinking about the topic for the week. Some people may want to tell a long story in response to one of these questions, but the goal is to keep the answers brief. Ideally, you want everyone in the group to get a chance to answer, so try to keep the responses to a minute or less. If you have talkative group members, say up front that everyone needs to limit his or her answer to one minute.

Give the group members a chance to answer but tell them to feel free to pass if they wish. With the rest of the study, it's generally not a good idea to have everyone answer every question—a free-flowing discussion is more desirable. But with the opening icebreaker questions, you can go around the circle. Encourage shy people to share, but don't force them.

PREPARING YOUR GROUP FOR THE STUDY

Before watching your first video at your first meeting, let the group members know that each session contains three days' worth of Bible study and reflection materials to complete during the week. While the personal study is optional, it will help the members cement the concepts presented during the group study time and encourage them to spend time each day in God's Word. The *Beautiful Word Bible Studies* series is designed so each participant reads through the entire book of the Bible being studied over the course of the personal study exercises. One of the most lamented aspects of all church ministry is struggling to get people to read their Bibles on their own. We have made reading a book of the Bible as simple and engaging as ever and your group members will not believe what they get out of spending time each week engaging God's Word for themselves!

Also, invite your group members to bring any questions and insights they uncovered while reading to your next meeting, especially if they had a breakthrough moment or if they didn't understand something.

WEEKLY PREPARATION

As the leader, there are a few things you should do to prepare for each meeting:

- *Watch the video.* This will help you to become familiar with the content Lisa is presenting and give you foresight of what may or may not be brought up in the discussion time.

- *Read through the group discussion section.* This will help you to become familiar with the questions you will be asking and allow you to better determine how to structure the discussion time for your group.

- *Decide which questions you definitely want to discuss.* Based on the amount and length of group discussion, you may not be able to get through all the questions, so choose four to five questions that you want to cover.

- *Be familiar with the questions you want to discuss.* Every group has times when there are no respondents, and the question falls flat out of the gate. This is normal and okay! Be prepared with YOUR answer to the questions so you can always offer to share as an icebreaker and example. What you want to avoid is always answering the questions and therefore speaking for the group. Foremost, encourage members of the group to answer questions.

- *Remind your group there are no wrong answers or dumb questions.* Note that in many cases there will be no one "right" answer to the question. Answers will vary, especially when the group members are being asked to share their personal experiences.

- *Pray for your group.* Pray for your group members throughout the week and ask God to lead them as they study his Word.

- *Bring extra supplies to your meeting.* The members should bring their own pens for writing notes, but it's a good idea to have extras available for those who forget. You may also want to bring paper and additional Bibles.

STRUCTURING THE DISCUSSION TIME

You will need to determine with your group how long you want to meet each week so you can plan your time accordingly. Generally, most groups like to meet for either sixty minutes or ninety minutes, so you could use one of the following schedules:

SECTION	60 MINUTES	90 MINUTES
INTRODUCTION (Members arrive and get settled; leader reads or summarizes the introduction.)	5 minutes	10 minutes
OPENING ACTIVITY	10 minutes	15 minutes
VIDEO NOTES (Watch the teaching video together and take notes.)	15 minutes	15 minutes
GROUP DISCUSSION (Discuss the Bible study questions you selected ahead of time.)	25 minutes	40 minutes
CLOSING PRAYER (Pray together as a group and dismiss.)	5 minutes	10 minutes

As the group leader, it is up to you to keep track of the time and keep things moving along according to your schedule. You might want to set a timer for each segment so both you and the group members know when your time is up. (Note: There are some good phone apps for timers that play a gentle chime or other pleasant sound instead of a disruptive noise.)

Don't be concerned if the group members are quiet or slow to share. People are often quiet when they are pulling together their ideas, and this might be a new experience for them. Just ask a question and let it hang in the air until someone shares. You can then say, "Thank you. What about others? What came to you when you watched that portion of the video?"

GROUP DYNAMICS

Leading a group through *Luke* will prove to be highly rewarding both for you and your group members. However, this doesn't mean you will not encounter any challenges along the way! Discussions can get off track. Group members may not be sensitive to the needs and ideas

of others. Some might worry they will be expected to talk about matters that make them feel awkward. Others may express comments that result in disagreements. To help ease this strain on you and the group, consider the following ground rules:

- When someone raises a question or comment that is off the main topic, suggest you deal with it another time, or, if you feel led to go in that direction, let the group know you will be spending some time discussing it.

- If someone asks a question you don't know how to answer, admit it, and move on. At your discretion, feel free to invite group members to comment on questions that call for personal experience.

- If you find one or two people are dominating the discussion time, direct a few questions to others in the group. Outside the main group time, ask the more dominating members to help you draw out the quieter ones. Work to make them a part of the solution instead of the problem.

- When a disagreement occurs, encourage the group members to process the matter in love. Encourage those on opposite sides to restate what they heard the other side say about the matter, and then invite each side to evaluate if that perception is accurate. Lead the group in examining other Scriptures related to the topic and look for common ground.

When any of these issues arise, encourage your group members to follow these words from the Bible: "Love one another" (John 13:34), "If it is possible, as far as it depends on you, live at peace with everyone" (Romans 12:18), and "Be quick to listen, slow to speak and slow to become angry" (James 1:19). This will make your group time more rewarding and beneficial for everyone who attends.

SESSION BY SESSION OVERVIEWS

SESSION ONE: OUTLIERS, OUTCASTS, AND THE OUTRAGEOUS MERCY OF GOD

Scripture covered in this session: **Luke 8:1–3, Luke 16:19–31, Luke 18:9–14**

Scripture to study and read this week: **Luke chapters 1–2**

Verse of the Week: "And my spirit rejoices in God my Savior, for he has been mindful of the humble state of his servant. From now on all generations will call me blessed" (Luke 1:47–48).

Discussion Question choices / notes:

PRAYER REQUESTS

SESSION TWO: WORSHIP IN THE WAITING

Scripture covered in this session: **Luke 2:1–20, Luke 2:22–33, 36–38**

Scripture to study and read this week: **Luke chapters 3–4.**

Verse of the Week: She never left the temple but worshiped night and day, fasting and praying (Luke 2:37).

Discussion Question choices / notes:

PRAYER REQUESTS

SESSION THREE: UPHILL GLORY

Scripture covered in this session: **Luke 4:1–28**

Scripture to read this week: **Luke 4:1–7:15**

Verse of the Week: "The Spirit of the Lord is on me, because he has anointed me to proclaim good news to the poor. He has sent me to proclaim freedom for the prisoners and recovery of sight for the blind, to set the oppressed free, to proclaim the year of the Lord's favor" (Luke 4:18–19).

Discussion Question choices / notes:

PRAYER REQUESTS

SESSION FOUR: GUT-LEVEL COMPASSION

Scripture covered in this session: **Luke 5:12–13, Luke 7:11–15**

Scripture to read this week: **Luke 5:12–10:37**

Verse of the Week: When the Lord saw her, his heart went out to her and he said, "Don't cry" (Luke 7:13).

Discussion Question choices / notes:

PRAYER REQUESTS

SESSION FIVE: THE TENDER HEART OF OBEDIENCE

Scripture covered in this session: **Luke 10:25–37**

Scripture to study and read this week: **Luke 10:25–13:17**

Verse of the Week: "Go and do likewise" (Luke 10:37).

Discussion Question choices / notes:

PRAYER REQUESTS

SESSION SIX: A BEAUTIFUL UNBENDING

Scripture covered in this session: **Luke 13:10–17**

Scripture to study and read this week: **Luke 13:18–16:31; 22:39–62**

Verse of the Week: When Jesus saw her, he called her forward and said to her, "Woman, you are set free from your infirmity" (Luke 13:12).

Discussion Question choices / notes:

PRAYER REQUESTS

SESSION SEVEN: A MOST RADICAL RESTORATION

Scripture covered in this session: **Luke 5:1–11; 22:39–62**

Scripture to study and read this week: **Luke 17:1–22:34**

Verse of the Week: "Put out into deep water, and let down the nets for a catch" (Luke 5:4).

Discussion Question choices / notes:

PRAYER REQUESTS

SESSION EIGHT: A TALE OF TWO ROOMS

Scripture covered in this session: **Luke 22:7–34, Acts 1:6–14**

Scripture to study and read this week: **Luke 22:7–24:53**

Verse of the Week: "The greatest among you should be like the youngest, and the one who rules like the one who serves" (Luke 22:26).

Discussion Question choices / notes:

PRAYER REQUESTS

SCRIPTURE MEMORY CARDS

SESSION 1

"And my spirit rejoices in God my Savior, for he has been mindful of the humble state of his servant. From now on all generations will call me blessed" (Luke 1:47–48).

SESSION 2

She never left the temple but worshiped night and day, fasting and praying (Luke 2:37).

SESSION 3

"The Spirit of the Lord is on me, because he has anointed me to proclaim good news to the poor. He has sent me to proclaim freedom for the prisoners and recovery of sight for the blind, to set the oppressed free, to proclaim the year of the Lord's favor" (Luke 4:18–19).

SESSION 4

When the Lord saw her, his heart went out to her and he said, "Don't cry" (Luke 7:13).

SESSION 5

"Go and do likewise"

(Luke 10:37).

SESSION 6

When Jesus saw her, he called her forward and said to her, "Woman, you are set free from your infirmity"

(Luke 13:12).

SESSION 7

"Put out into deep water, and let down the nets for a catch"

(Luke 5:4).

SESSION 8

"The greatest among you should be like the youngest, and the one who rules like the one who serves"

(Luke 22:26).

ABOUT THE AUTHOR

Lauded as a "hilarious storyteller" and "theological scholar," **Lisa Harper** is anything but stereotypical! She is known for emphasizing that accruing knowledge about God pales next to a real and intimate relationship with Jesus.

Lisa has 30+ years of church and para-church ministry leadership, as well as a decade speaking on-tour with "Women of Faith." She holds a Master of Theological Studies from Covenant Seminary and is in the thesis stage of an earned doctorate at Denver Seminary.

She is a regular on TBN's globally syndicated *Better Together* show and has published multiple books and Bible studies. Lisa has also been leading the same weekly Bible study in her neighborhood for 15 years.

The most noticeable thing about Lisa Harper is her authenticity and love for Christ. But her greatest accomplishment to date is getting to become Missy's mom through the miracle of adoption in 2014!

Discover the Beauty of God's Word

The Beautiful Word™ Bible Study Series helps you connect God's Word to your daily life through vibrant video teaching, group discussion, and deep personal study that includes verse-by-verse reading, Scripture memory, coloring pages. Get ready to receive your own beautiful Word from God.

In each study, a central theme—a beautiful word—threads throughout the book, helping you apply Scripture to your daily life today, and forever.

IN THIS SERIES:

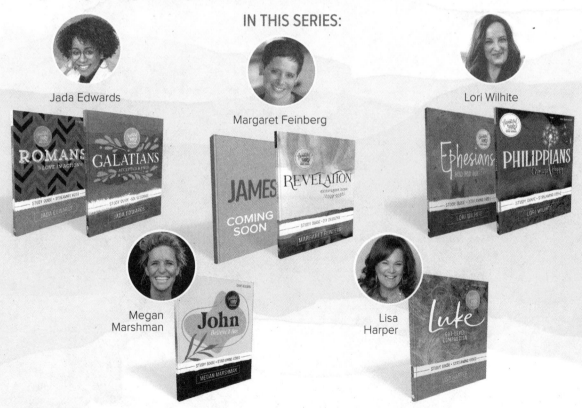

Each Bible study INCLUDES STREAMING VIDEO TEACHING available on StudyGateway.